Cherish Me Always

A Century of Dolls

Antique
Photographs
of Children
with Dolls

by Steven Micheal Wikert and Mary McMurray Wikert

Published by Hobby House Press, Inc.
Grantsville, Maryland
www.hobbyhouse.com

*This book is dedicated to Jim and Janet Doud,
our dear friends and kindred spirits*

Acknowledgements

We would like to thank the following people for their special encouragement, advice, and generosity: Jim and Janet Doud, Virginia McMurray, Spencer Wikert, Alan and Marion Wikert, Dr. Solomon Wikert, Dr. Jessica Wikert, Cindy Blow, Sherryl Newton, Mary Kangas, Barbara Corson, Delores Prochaska, June Anderson, Rosemary Beach, Craig and Anita Johnson, Mimi Dietrich, Karan Flanscha, Laara Duggan, Lori Farmer, Don Johnson, James L. Jackson, J.J. Murphy, the members of the Prairie Rapids Doll Club of Iowa, Gary Ruddell, Sherry White, and the staff of Hobby House Press.

Every effort has been made to correctly identify all materials in this book and present them in a dignified and historical manner. Unfortunately most of the photos in this book were abandoned when transfers of ownership occurred and had little if any information associated with them or their original places of origin. Similarities to other persons or events may be purely coincidental. If errors or concerns have been created it was unintentional, and with adequate reasons or information we will be happy to correct them in future editions.

Front Cover Photo:
3½in x 5¼in (9cm x 13cm)
The photographer's lighting emphasizes the face of the child and the German bisque head dolly-face doll in this studio silver print of the 1890s. This doll has glass eyes and an open mouth with teeth.
Previous Page Photo: Fig. 1
3in x 4in (8cm x 10cm)
The young girl in this studio silver print proudly holds a large example of a German patent washable papier-mâché doll made between 1880-1915. Both are wearing heart locket necklaces.
Back Cover Photo:
3¼in x 4in (8cm x 10cm)
This unusual albumen image of the early 20th century portrays a young girl with a camera, barefoot in the grass. *Sherryl Newton Collection.*

Additional copies of this book may be purchased at $19.95 (plus postage and handling) from
Hobby House Press, Inc.
1 Corporate Drive, Grantsville, MD 21536
1-800-554-1447
www.hobbyhouse.com
or from your favorite bookstore or dealer.

Printed in the United States of America

ISBN: 0-87588-603-5

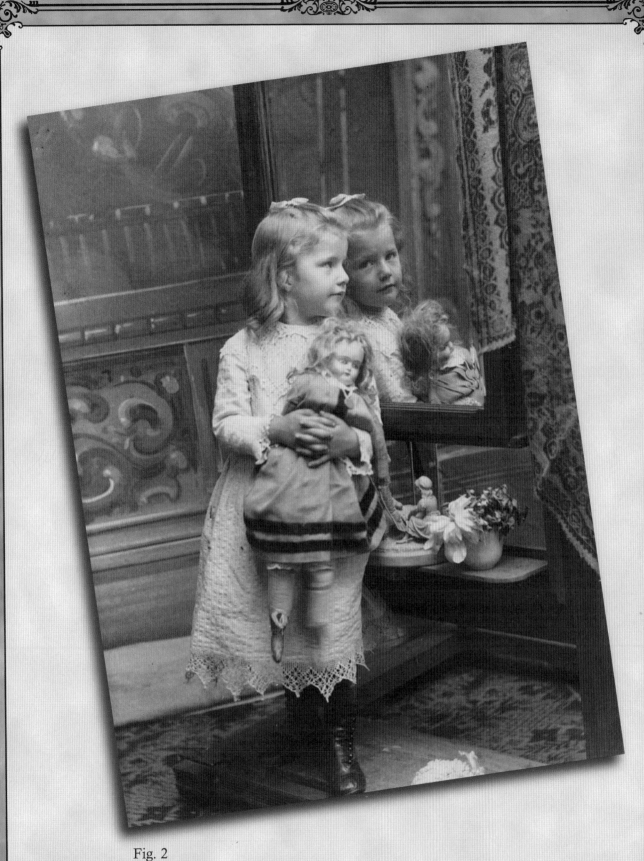

Fig. 2
4in x 5½in (10cm x 14cm)
This artistic albumen photograph portrays a young girl of the 1890s holding her German bisque head doll with a closed mouth. The mirror portrait and tousled condition of the doll add to the charm of this image. *Cindy Blow Collection.*

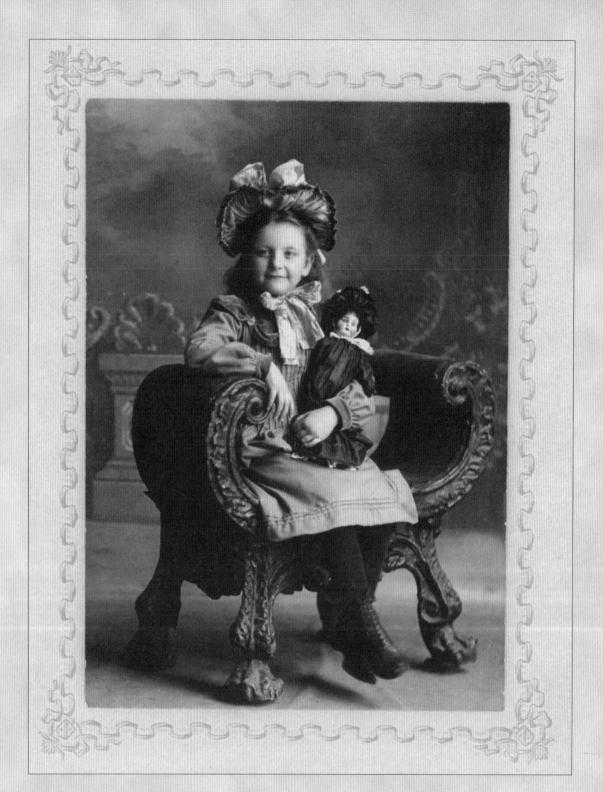

Fig 3
3½in x 4½in (9cm x 12cm)
An elegantly dressed girl of the 1890s proudly holds her German dolly-face doll
made to represent an idealized version of a beautiful full-faced child. The molded
bisque head doll in this studio silver print has glass eyes, an open mouth with teeth,
and a mohair or human hair wig.

4

Cherish Me Always

I am the trainer of parental care,
That doll in your bed, your lap or chair.

I am made of cloth, compo, or clay,
Loved like a person when time to play.

Tiny hands caress my head,
Memories fade, but are never dead.

Children have placed me on a throne,
My majestic soul mirrors their own.

I'm the doll you loved your earliest days,
So please, please, Cherish Me Always.

S.M. Wikert

5

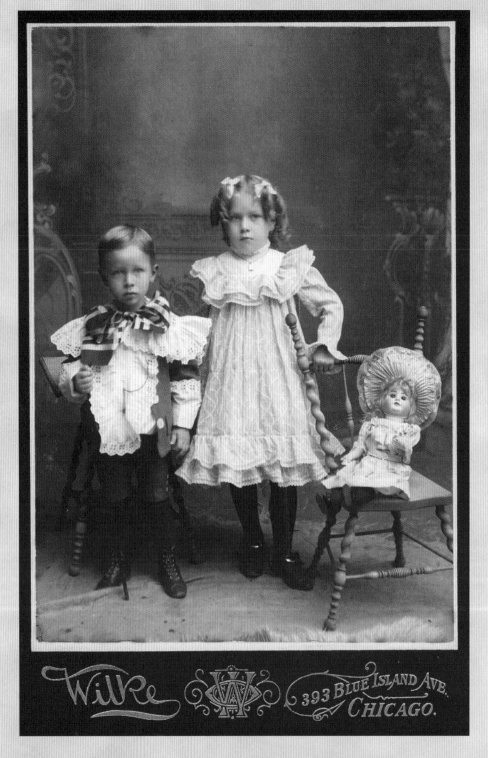

Wilke

393 BLUE ISLAND AVE. CHICAGO.

Fig. 4
4½in x 6in (12cm x 15cm)
The children in this silver print cabinet card are obviously from an affluent family and are dressed in stylish outfits from the 1890s. The boy wears a fancy lace-trimmed blouse. The girl's dress has a double-flounced bertha collar and hem. The bisque head doll's fancy bonnet has a shirred brim. *Jim and Janet Doud Collection.*

Introduction

The enchantment of viewing old photographs of children with their cherished dolls has fascinated both of us for over a decade of collecting. It does not matter if the child is dressed in fancy Victorian finery with polished high button shoes or in disheveled torn clothing with patches and stains – the child's youthful face is recorded equally well by the objectivity of the camera lens. We have spent countless hours, searching in a multitude of places, to rediscover the often abandoned and illusive images of children with their dolls before they are lost forever.

The examples of photographs published on the following pages are historical treasures. As more collectors are joining the search, finding excellent images of children with their dolls becomes increasingly difficult and more costly. We feel there are many factors to consider when purchasing a photograph from the past: the type of image, the clarity of the image, the condition of the image, the rarity of the doll or notoriety of the person in the image, the aesthetic quality of the image, and finally the price.

We hope our sampling will give our readers an overview of the great variety of dolls belonging to children of the past. Although accurate identification of the photograph type is usually possible, exact attributions of certain dolls may not be as precise. Without physically examining the doll in question, we can only research and point out visual similarities, which may suggest a possible provenance of a given maker. In some cases, the exact dating of the photographs is made very easy by referring to written dates, postmarks, and stamp boxes. When these are not available, approximate dates can be determined by examining various clues such as image type, style of clothing, photo presentation, and the various dolls included in these historical portraits. Measurements listed with each caption pertain to the original photographic dimensions, even though the format and size of the image may have been edited to compliment this book.

Each of our photographic discoveries becomes a magical portal into history. We are allowed to become time travelers as we view and study each image that demonstrates the relationships between the child and their cherished doll. On an even larger plane, we recognize that these photographs record the relationship of the child learning to become a good mother or father. Collecting these images lets us marvel at how life has changed during the past 150 years. However, these photographs also illustrate that the needs for belonging, enjoying life, and giving love are enduring and untouched by time.

Please refer to the Guide to Photographic Terms and the Doll Glossary in the back of this book for help in identifying and understanding the various photographic processes and doll types, many of which are represented in this volume. The Selected Bibliography gives a list of sources that will offer more detailed information on photography of the past as well as historic information about dolls and children's clothing styles.

It is rewarding for us to share these historical photographs and give them the attention they so richly deserve in this book format. We are truly thankful for the opportunity to be guardians of these photographic treasures during our lifetimes and we hope that these images will indeed be cherished always.

<div style="text-align: right">

Mary McMurray Wikert
Steven Micheal Wikert

</div>

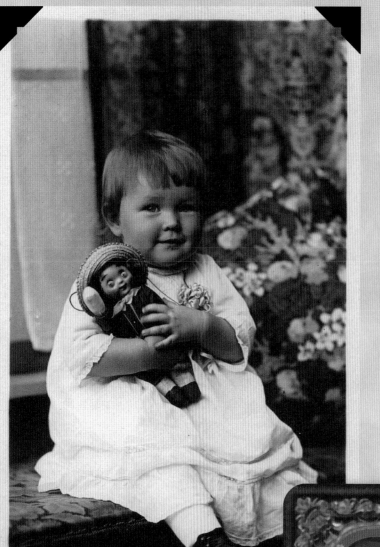

Fig. 5 (left)
3½in x 5½in (9cm x 14cm)
The German googly-eyed doll in this real photo postcard appears to be waving at the camera. This composition and cloth doll resembles the German "Hug-Me-Kiddy" doll produced by Samstag & Hilder and sold as a premium by *McCall's* magazine in 1912 and 1913.

Fig. 6 (right)
2½in x 3in (6cm x 8cm)
The camera has captured this rare early image of a girl of the 1850s wearing a coral necklace and holding her doll, probably made of papier-mâché or china. The print of the doll's dress is a diminutive version of the garment worn by her proud young owner in this cased ambrotype.

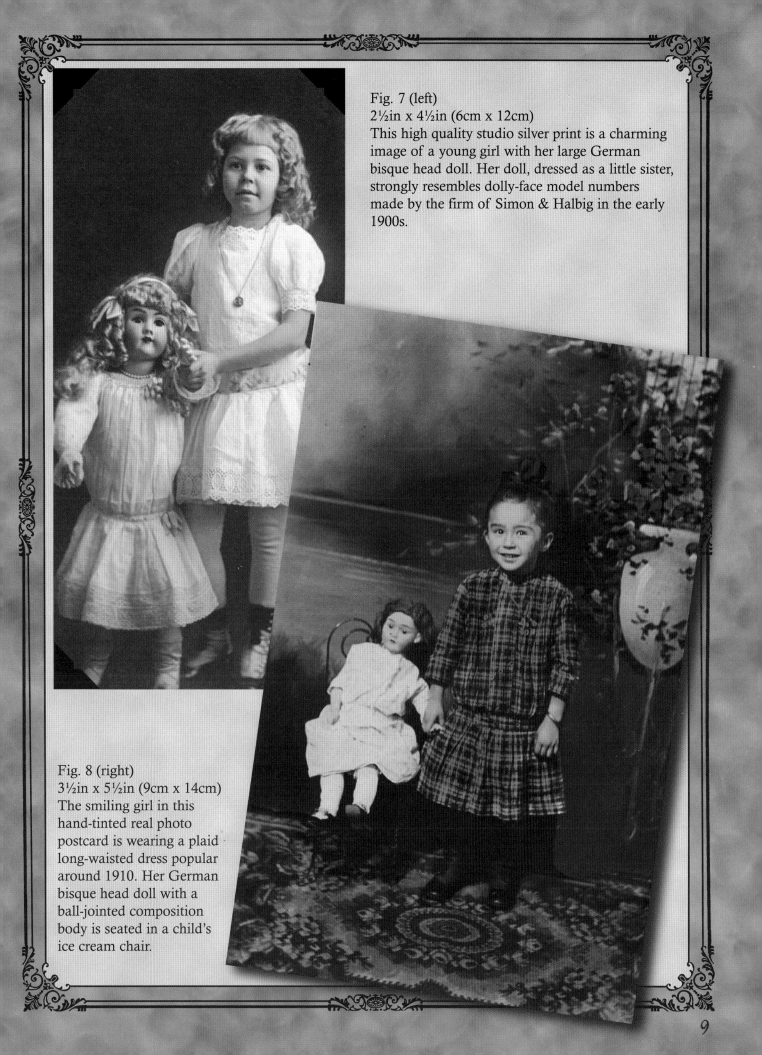

Fig. 7 (left)
2½in x 4½in (6cm x 12cm)
This high quality studio silver print is a charming image of a young girl with her large German bisque head doll. Her doll, dressed as a little sister, strongly resembles dolly-face model numbers made by the firm of Simon & Halbig in the early 1900s.

Fig. 8 (right)
3½in x 5½in (9cm x 14cm)
The smiling girl in this hand-tinted real photo postcard is wearing a plaid long-waisted dress popular around 1910. Her German bisque head doll with a ball-jointed composition body is seated in a child's ice cream chair.

9

Fig. 9
8½in x 6in (22cm x 15cm)
This photogravure was photomechanically printed on sheer tissue paper in a nursery rhyme book printed in 1893. Five little girls each cradle their dolls, bordered by a hand-scripted lullaby. *Jim and Janet Doud Collection.*

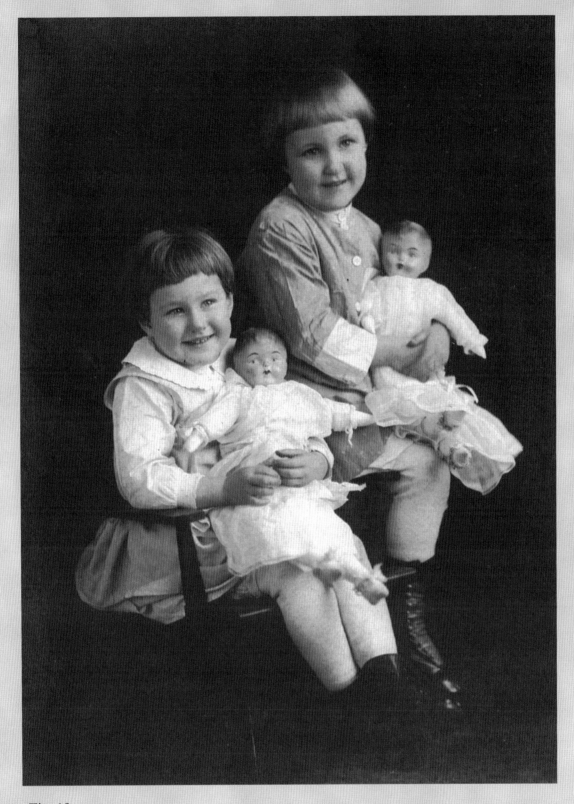

Fig. 10
3¾in x 6in (10cm x 15cm)
The two sisters in this studio silver print gaze adoringly at the camera while holding twin composition baby dolls in long white dresses. These dolls resemble examples made by Effanbee in the United States before 1920. *Jim and Janet Doud Collection.*

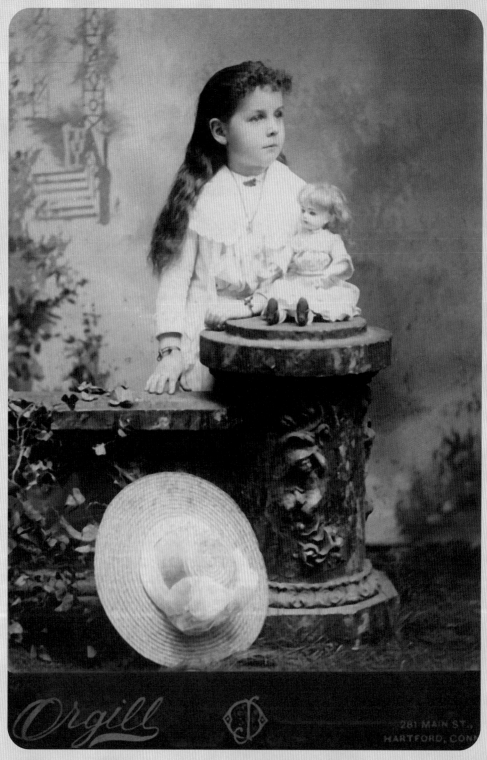

Fig. 11
4¼in x 6½in (11cm x 17cm)
This rare albumen cabinet card of the 1880s shows a well-dressed young girl and a bisque head doll, which closely resembles a Bébé Breveté. This type of doll, made by Casimer Bru in Paris, France, is highly sought after by doll collectors because of its rarity and great beauty. Her high-heeled shoes and dress may be her original outfit.

Fig. 12 (right)
3½in x 5½in (9cm x 14cm)
A young girl in a smocked dress
smiles for the camera as she holds
her large doll, possibly made of
composition, in this real European
photo postcard circa 1930.

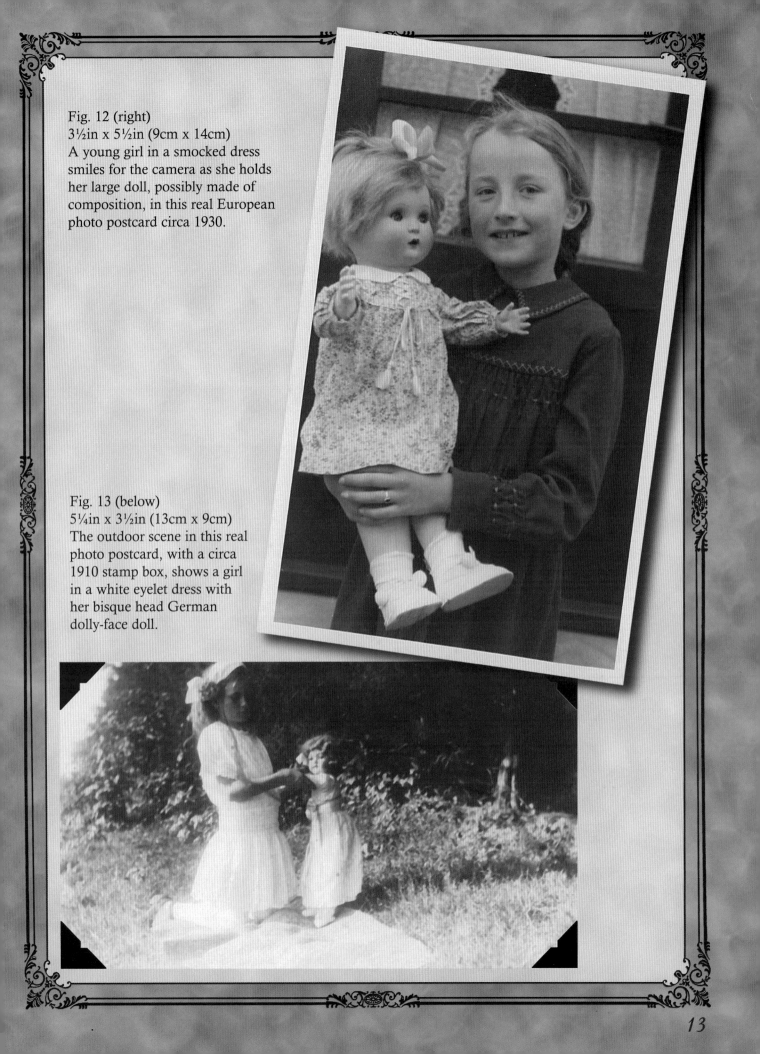

Fig. 13 (below)
5¼in x 3½in (13cm x 9cm)
The outdoor scene in this real
photo postcard, with a circa
1910 stamp box, shows a girl
in a white eyelet dress with
her bisque head German
dolly-face doll.

Fig. 14 (left)
2¾in x 4½in (7cm x 12cm)
This nostalgic snapshot of a young girl with her saddle shoes and hard plastic bride doll is typical of the 1950s. American doll companies such as Madame Alexander, American Character, Arranbee, Effanbee, and Ideal all produced dolls similar to this model.

Fig. 15 (below)
5½in x 3¼in (14cm x 8cm)
This real photo postcard, with a circa 1910 stamp box, portrays a little girl and woman enjoying the sunshine on a front porch. The doll, probably produced by Art Fabric Mills, was printed on cloth to be sewn and stuffed at home.

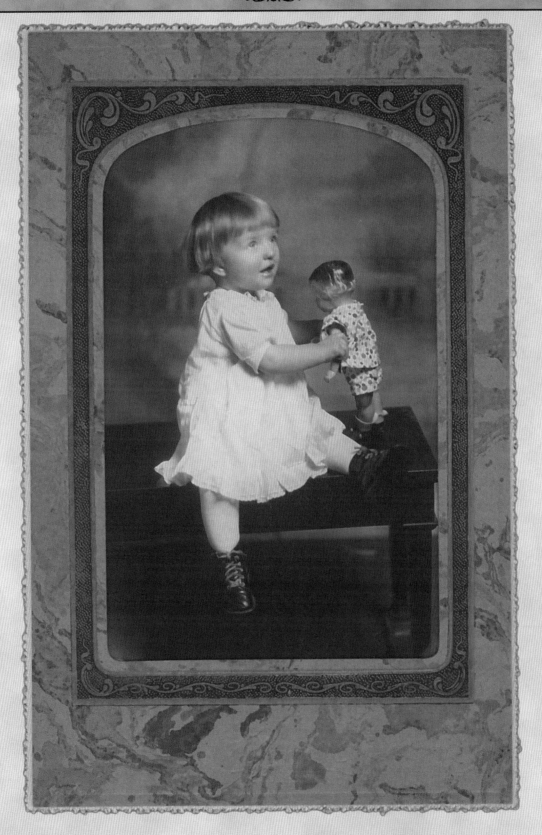

Fig. 16
4in x 6in (10cm x 15cm)
A toddler girl holds her molded hair composition doll as she poses on a bench
in this studio silver print of the 1920s.

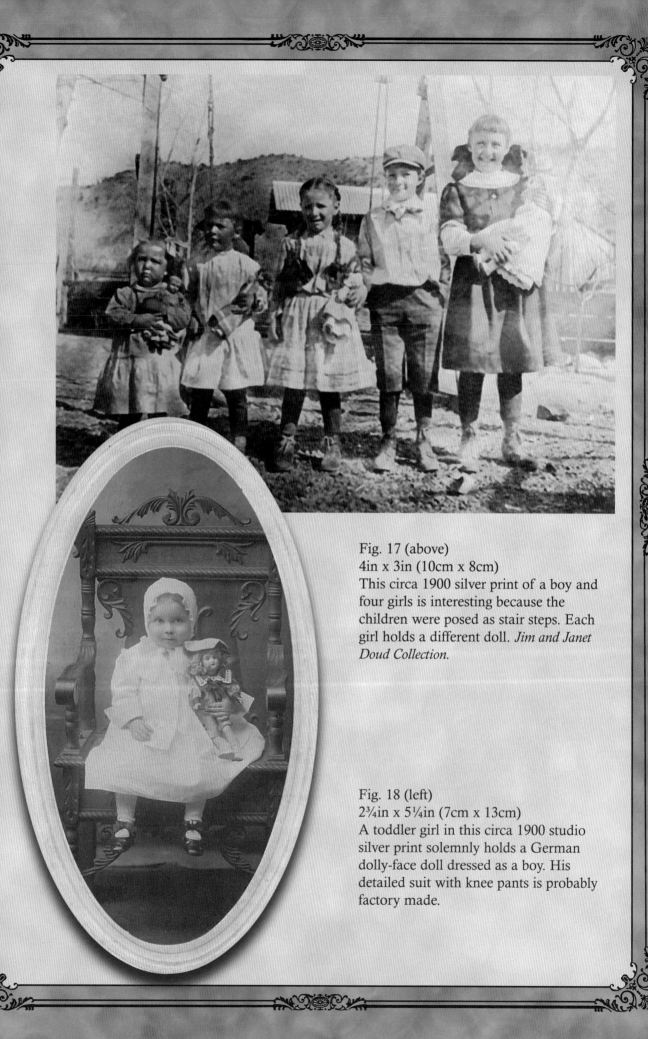

Fig. 17 (above)
4in x 3in (10cm x 8cm)
This circa 1900 silver print of a boy and four girls is interesting because the children were posed as stair steps. Each girl holds a different doll. *Jim and Janet Doud Collection.*

Fig. 18 (left)
2¾in x 5¼in (7cm x 13cm)
A toddler girl in this circa 1900 studio silver print solemnly holds a German dolly-face doll dressed as a boy. His detailed suit with knee pants is probably factory made.

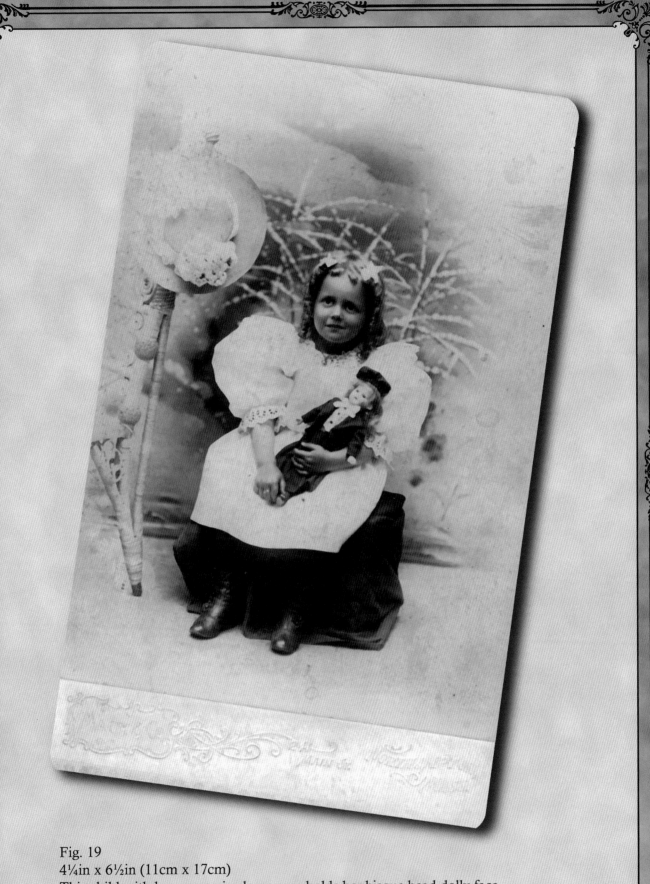

Fig. 19
4¼in x 6½in (11cm x 17cm)
This child with her expressive large eyes holds her bisque head dolly-face
German doll. The girl's large puffed sleeves were considered very stylish
in the 1890s in this albumen cabinet card. *Jim and Janet Doud Collection.*

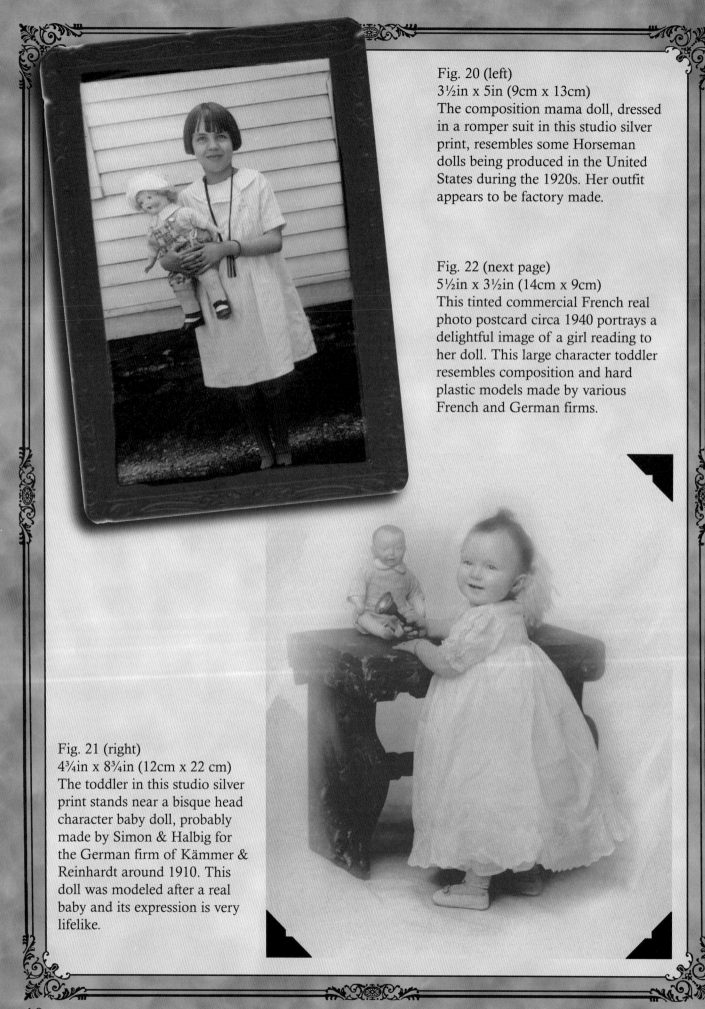

Fig. 20 (left)
3½in x 5in (9cm x 13cm)
The composition mama doll, dressed in a romper suit in this studio silver print, resembles some Horseman dolls being produced in the United States during the 1920s. Her outfit appears to be factory made.

Fig. 22 (next page)
5½in x 3½in (14cm x 9cm)
This tinted commercial French real photo postcard circa 1940 portrays a delightful image of a girl reading to her doll. This large character toddler resembles composition and hard plastic models made by various French and German firms.

Fig. 21 (right)
4¾in x 8¾in (12cm x 22 cm)
The toddler in this studio silver print stands near a bisque head character baby doll, probably made by Simon & Halbig for the German firm of Kämmer & Reinhardt around 1910. This doll was modeled after a real baby and its expression is very lifelike.

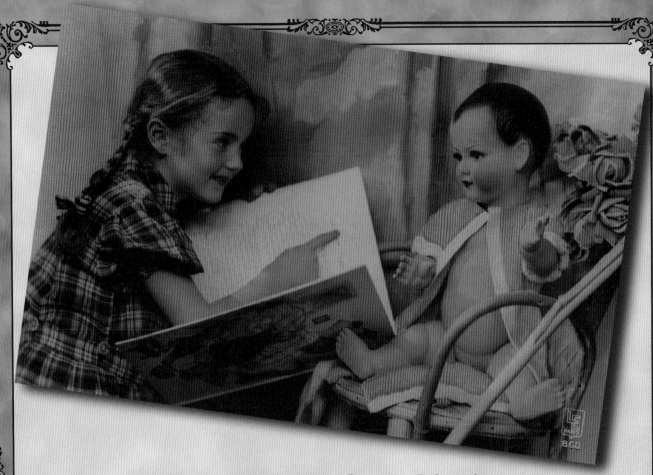

The Land of Story-Books

At evening when the lamp is lit,
Around the fire my parents sit;
They sit at home and talk and sing,
And do not play at anything...

...There, in the night, where none can spy,
All in my hunters camp I lie,
And play at books that I have read
Till it is time to go to bed...

...So, when my nurse comes in to me,
Home I return across the sea,
And go to bed with backwards looks
At my dear land of Story-Books.

Robert Louis Stevenson
A Child's Garden of Verses

19

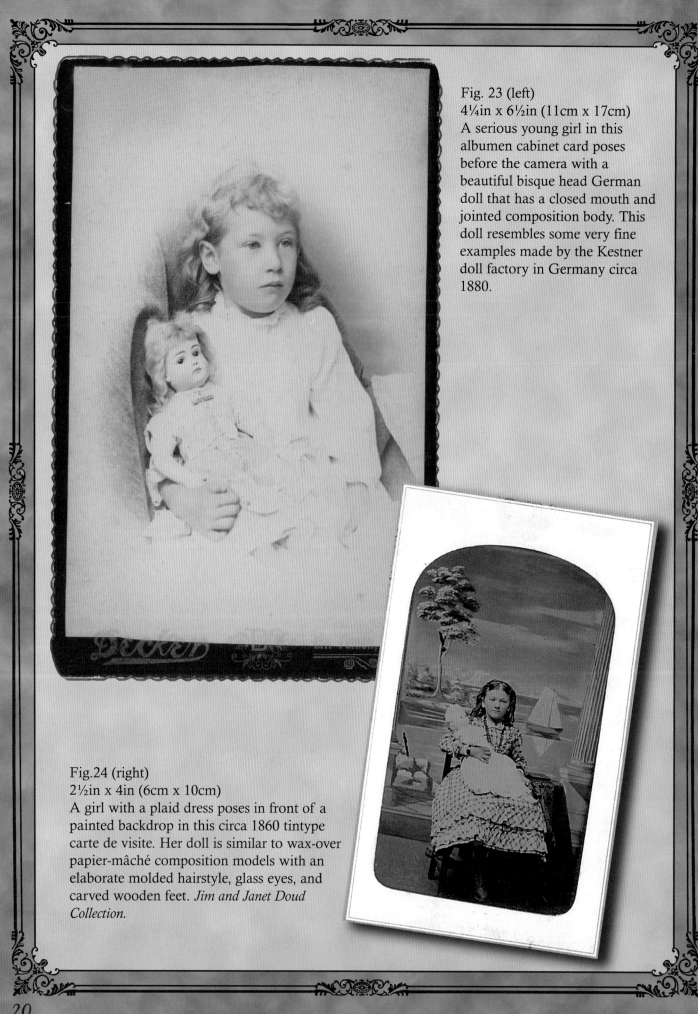

Fig. 23 (left)
4¼in x 6½in (11cm x 17cm)
A serious young girl in this albumen cabinet card poses before the camera with a beautiful bisque head German doll that has a closed mouth and jointed composition body. This doll resembles some very fine examples made by the Kestner doll factory in Germany circa 1880.

Fig.24 (right)
2½in x 4in (6cm x 10cm)
A girl with a plaid dress poses in front of a painted backdrop in this circa 1860 tintype carte de visite. Her doll is similar to wax-over papier-mâché composition models with an elaborate molded hairstyle, glass eyes, and carved wooden feet. *Jim and Janet Doud Collection.*

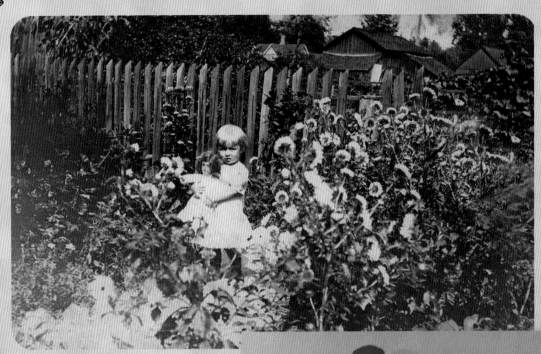

Fig. 25 (above)
5½in x 3½in (14cm x 9cm)
This real photo postcard, with
a circa 1910 stamp box,
displays an overgrown garden
scene. In the center stands a
small girl with her bisque head
German dolly-face doll. *Jim
and Janet Doud Collection.*

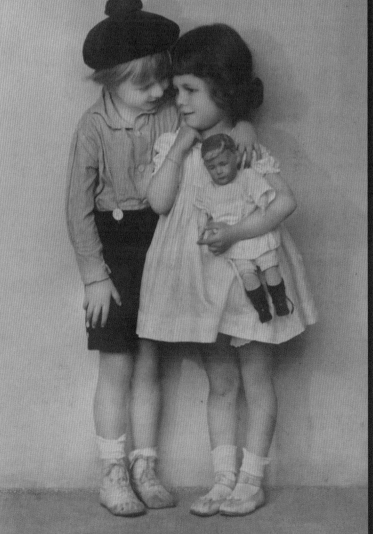

Fig. 26 (right)
3¼in x 5¼in (8cm x 13cm)
A young boy and girl stand
with a well-modeled
composition doll of probable
German origins. The doll's
character face and jointed
body are indicators of quality
in this European real photo
postcard dated 1919.

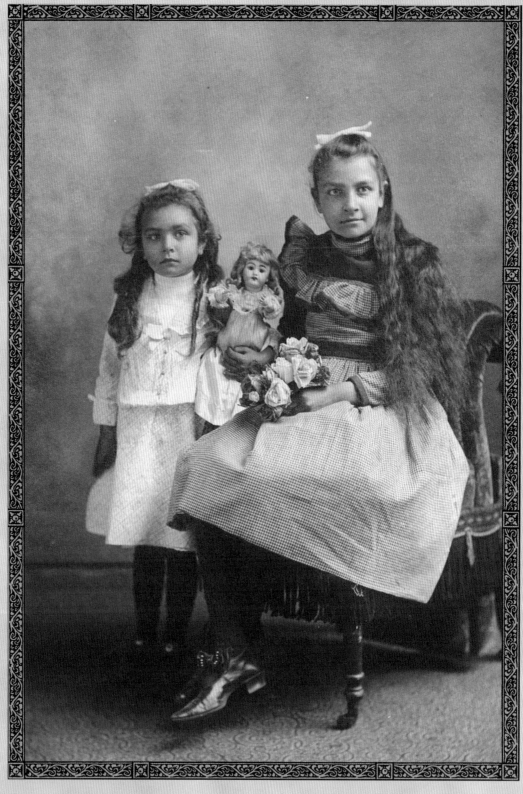

Fig. 27
4in x 5½in (10cm x 14cm)
These two girls are probably sisters and are dressed in their Sunday best for their studio silver print portrait of the 1890s. Their German bisque dolly-face doll resembles models produced by Simon & Halbig.

Fig. 28 (left)
3½in x 5½in (9cm x 14cm)
This real photo postcard, with a circa 1910 stamp box, is an interesting portrait of a girl by an open window. She holds a china head doll with a simple blond molded hairstyle, inexpensively produced and sold during this period.

Fig. 29 (right)
4in x 6in (10cm x 15cm)
A toddler stands with delight before the camera dressed in her pink bonnet and coat. About her neck is a muff complete with a doll's head, arms, and feet in this hand-tinted silver print dated 1923.

23

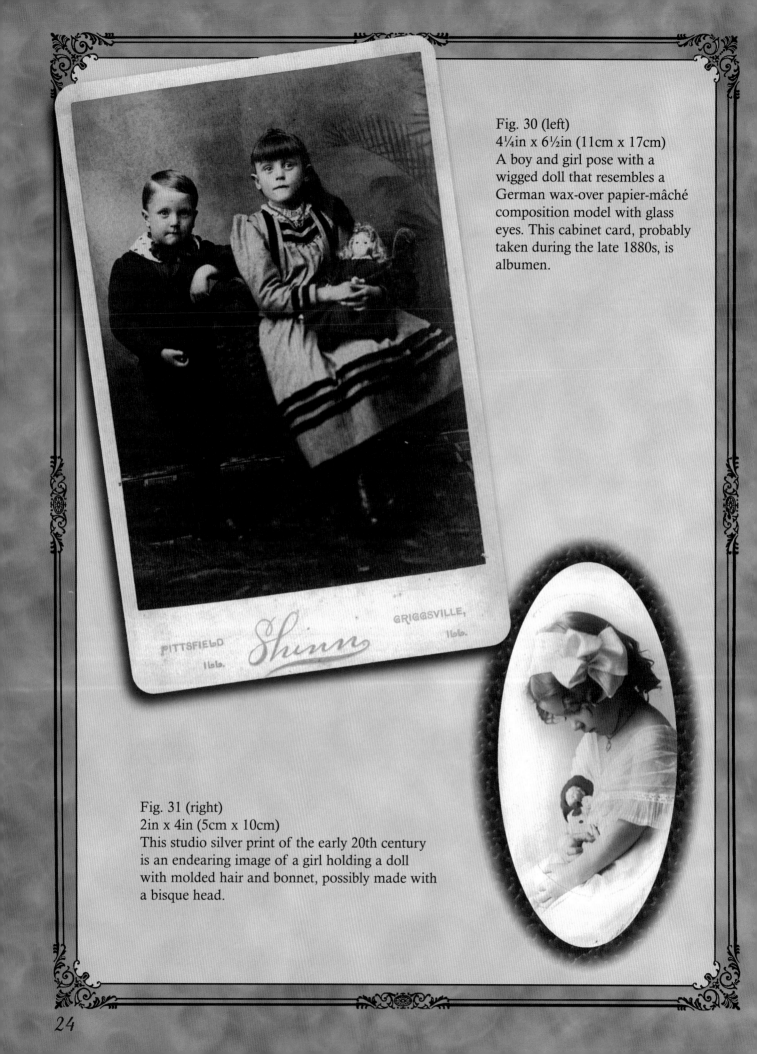

Fig. 30 (left)
$4\frac{1}{4}$in x $6\frac{1}{2}$in (11cm x 17cm)
A boy and girl pose with a wigged doll that resembles a German wax-over papier-mâché composition model with glass eyes. This cabinet card, probably taken during the late 1880s, is albumen.

Fig. 31 (right)
2in x 4in (5cm x 10cm)
This studio silver print of the early 20th century is an endearing image of a girl holding a doll with molded hair and bonnet, possibly made with a bisque head.

24

Fig. 32 (above)
5½in x 3½in (14cm x 9cm)
The camera has captured the image of a family in their home in this silver print of the 1920s. However, this photo is unusual because the bisque head doll located in the bottom right is wearing glasses. *Jim and Janet Doud Collection.*

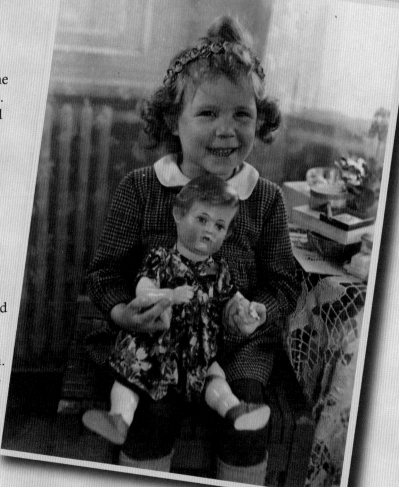

Fig. 33 (right)
3¼in x 5¼in (8cm x 13cm)
The character doll with molded hair in this European real photo postcard of the 1940s could be made of composition. The doll's young owner smiles broadly as they both gaze toward the camera.

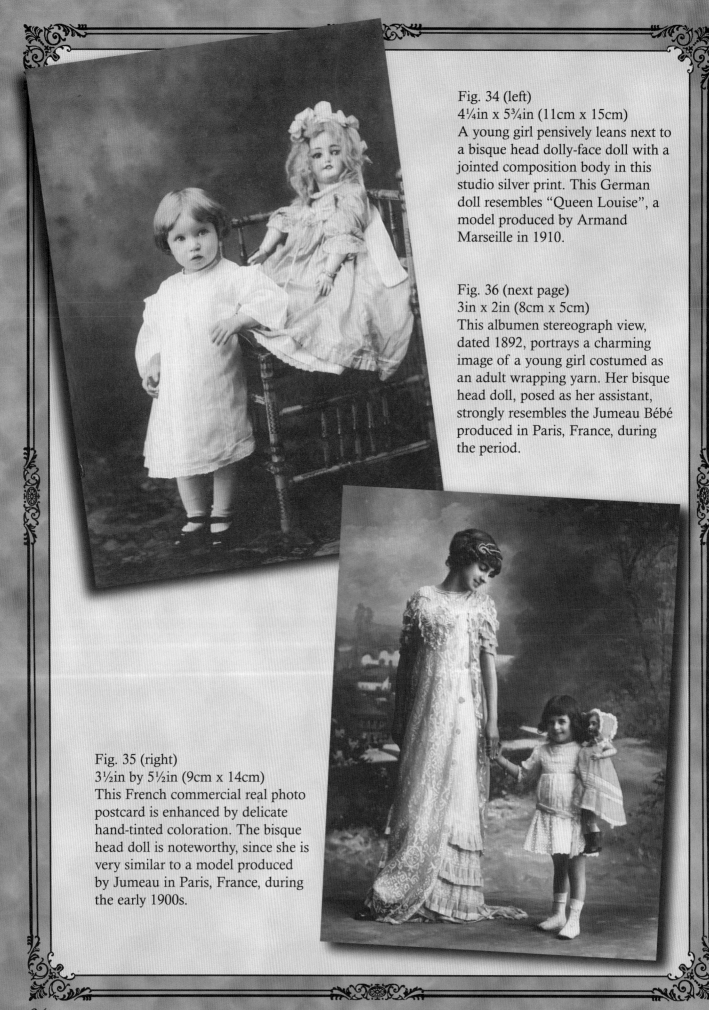

Fig. 34 (left)
$4\frac{1}{4}$in x $5\frac{3}{4}$in (11cm x 15cm)
A young girl pensively leans next to a bisque head dolly-face doll with a jointed composition body in this studio silver print. This German doll resembles "Queen Louise", a model produced by Armand Marseille in 1910.

Fig. 36 (next page)
3in x 2in (8cm x 5cm)
This albumen stereograph view, dated 1892, portrays a charming image of a young girl costumed as an adult wrapping yarn. Her bisque head doll, posed as her assistant, strongly resembles the Jumeau Bébé produced in Paris, France, during the period.

Fig. 35 (right)
$3\frac{1}{2}$in by $5\frac{1}{2}$in (9cm x 14cm)
This French commercial real photo postcard is enhanced by delicate hand-tinted coloration. The bisque head doll is noteworthy, since she is very similar to a model produced by Jumeau in Paris, France, during the early 1900s.

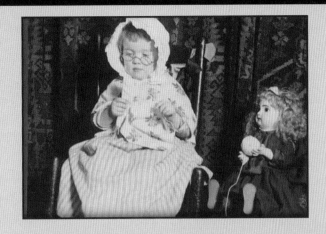

Grandma's Prayer

I pray that, risen from the dead,
I may in glory stand—
A crown, perhaps, upon my head,
But a needle in my hand.

I've never learned to sing or play,
So let no harp be mine;
From birth unto my dying day.
Plain sewing's been my line.

Therefore, accustomed to the end
To plying useful stitches,
I'll be content if asked to mend
The little angels' breeches.

Eugene Field
Poems of Childhood

27

Fig. 37 (right)
2½in x 3½in (6cm x 9cm)
A young girl poses in her elegant wide-brimmed
hat as she holds her closed mouth German
bisque head doll for the photographer. This
small albumen print, circa 1890, is an endearing
portrait to be treasured. *Jim and Janet Doud
Collection.*

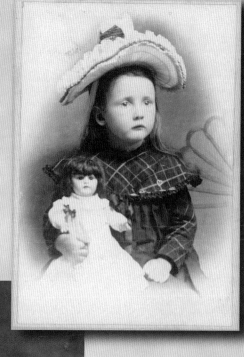

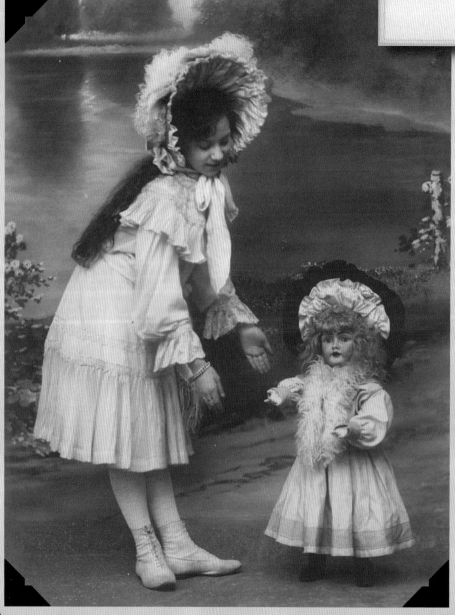

Fig. 38 (left)
3½in x 5½in (9cm x 14cm)
This European commer-
cial real photo postcard
is an image of a girl
beautifully dressed and a
doll exquisitely costumed
in feathers and a wire-
brimmed hat shirred with
silk. The bisque head
German doll is similar to
dolly-face models
produced by Simon &
Halbig around 1900.

28

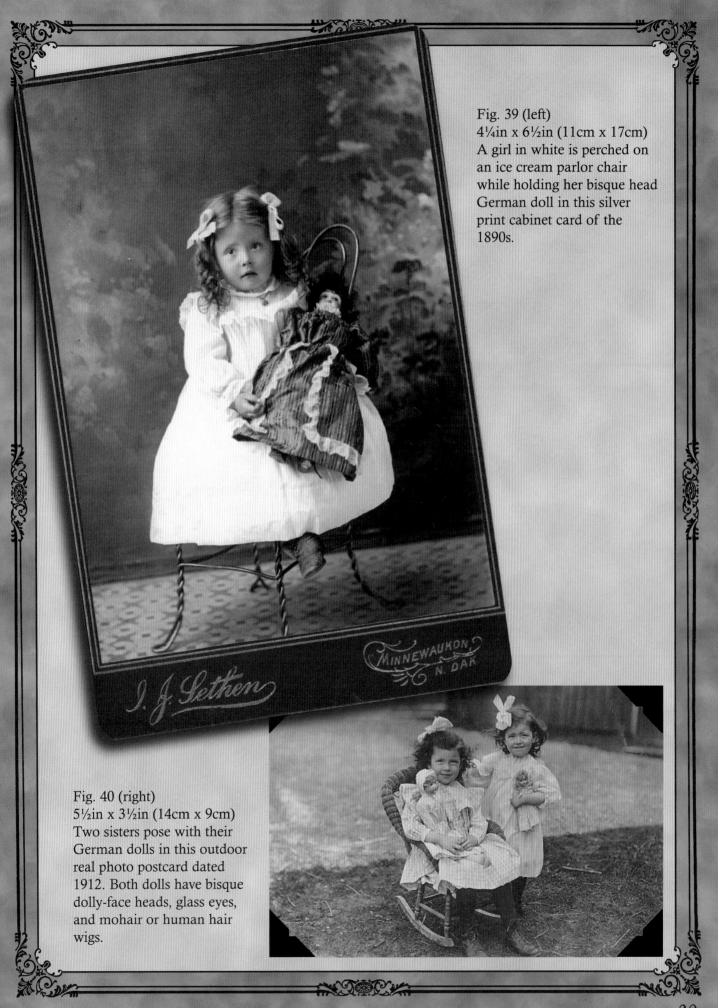

Fig. 39 (left)
4¼in x 6½in (11cm x 17cm)
A girl in white is perched on an ice cream parlor chair while holding her bisque head German doll in this silver print cabinet card of the 1890s.

I. J. Sethen

MINNEWAUKON, N. DAK.

Fig. 40 (right)
5½in x 3½in (14cm x 9cm)
Two sisters pose with their German dolls in this outdoor real photo postcard dated 1912. Both dolls have bisque dolly-face heads, glass eyes, and mohair or human hair wigs.

Fig. 41
3½in x 5½in (9cm x 14cm)
This colorful hand-tinted European real photo postcard of the 1920s portrays a girl cradling a baby doll in a crocheted dress and hat. This character model resembles composition or celluloid examples produced in Germany during this period.

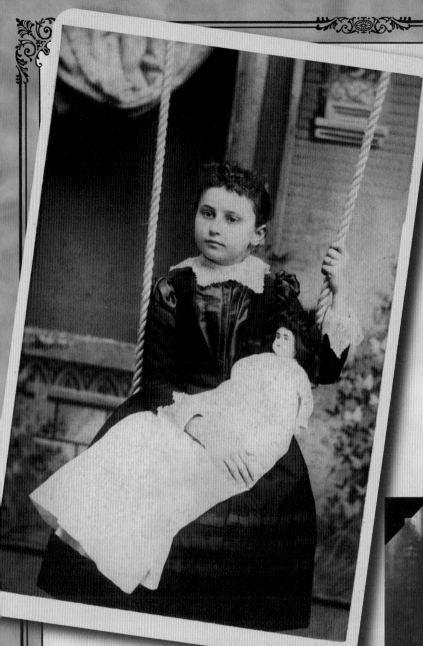

Fig. 42 (left)
4¼in x 6½in (11cm x 17cm)
The pose of a girl and doll on a swing in this albumen cabinet card image of the 1890s is unique. Her German bisque head doll, dressed in white, contrasts sharply against her dark satin trimmed dress with detachable collar. *Jim and Janet Doud Collection.*

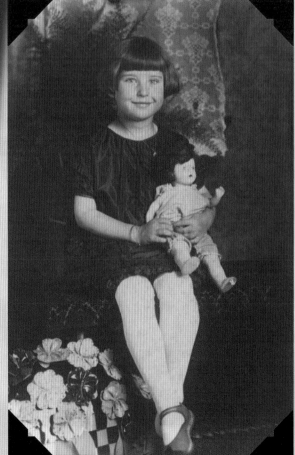

Fig. 43 (right)
3½in x 5in (9cm x 13cm)
A pleasantly smiling girl in this studio silver print holds a doll that resembles an American composition mama doll, popular from 1915-1925. Many of these dolls had cloth bodies, composition appendages and voice boxes that said "mama". *Jim and Janet Doud Collection.*

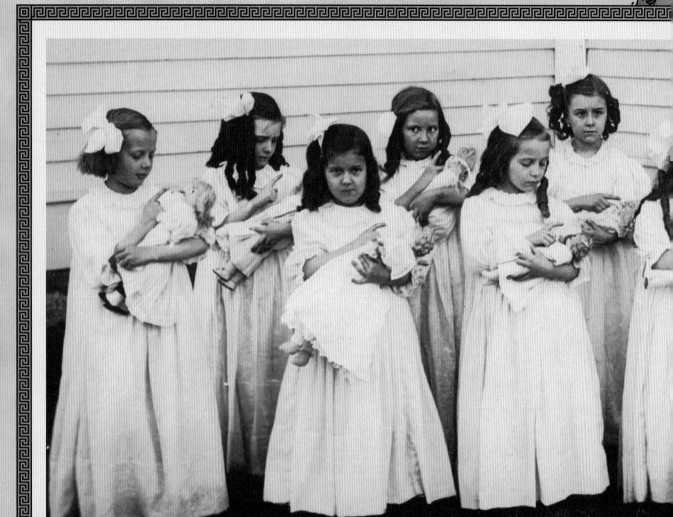

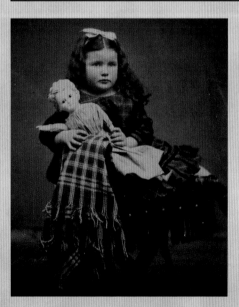

Fig. 44 (above)
5½in x 3½in (14cm x 9cm)
This real photo postcard, with a circa 1910 stamp box, is of a very desirable image of ten identically dressed young girls holding their dolls. The photographer has positioned each girl in a motherly pose, which illustrates the strong caring relationship between the child and her doll.

Fig. 45 (left)
2½in x 3½in (6cm x 9cm)
A photographer of the 1860s has captured a beautiful image of a young girl with her German doll in this tintype. This doll is probably a wax-over papier-mâché composition example.

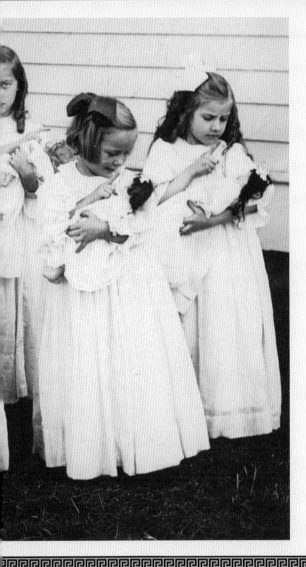

Because I feel that,
in the Heavens above,
The angels,
whispering to one another,
Can find, among the
burning terms of love,
None so devotional
as that of
"Mother,"...

From "To My Mother"
Edgar Allan Poe

Fig. 46 (right)
5½in x 3½in (14cm x 9cm)
A toddler cradles a German china head doll in this real photo postcard with a circa 1910 stamp box design. The doll's "low-brow" wavy hairstyle was a popular mold used on inexpensive models during this period.

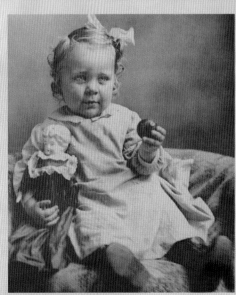

33

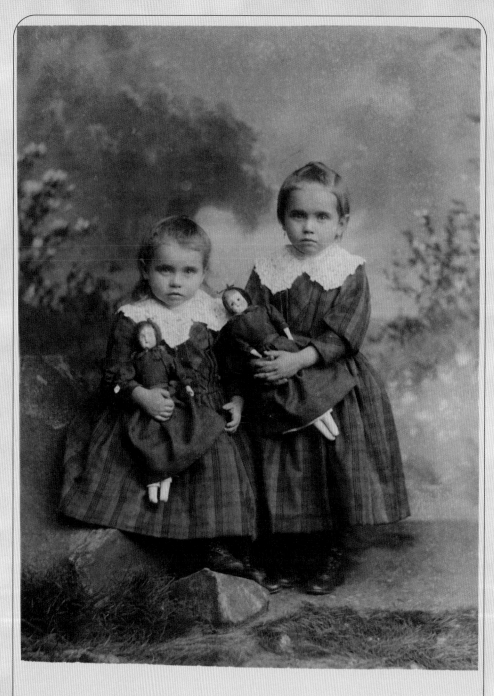

W.T.Crouch BELLEVILLE, ILL.

Fig. 47
4¼in x 6½in (11cm x 17cm)
Twin girls, dressed in identical plaid dresses with detachable lace collars, solemnly pose with their matching bisque head German dolly-face dolls in this circa 1890 albumen cabinet card.

Fig. 48 (left)
2½in x 4in (6cm x 10cm)
The German wigged doll held by the girl in this albumen carte de visite of the 1880s is stylishly dressed. This doll may have a head made of bisque or wax-over papier-mâché composition. *Jim and Janet Doud Collection.*

Fig. 49 (right)
3½in x 5½in (9cm x 14cm)
The dark sailor suit and tricorn hat of the young girl contrasts with her doll dressed in white. The doll resembles a Japanese traditional play doll with a papier-mâché head and dark glass eyes in this circa 1905 real photo postcard. *Jim and Janet Doud Collection.*

Fig. 50 (left)
4¾in x 6¼in (12cm x 16cm)
This studio silver print, dated 1915, is a charming portrait of a young girl holding her composition baby doll. Her corkscrew curls and shiny high button shoes are notable details.

Fig. 51 (below)
5½in x 3½in (14cm x 9cm)
This photomechanical halftone postcard, postmarked 1909, is identifiable by tiny dots in the image printed from a relief plate on paper. The 29 dolls carefully arranged around the little girl are made of bisque, composition, cloth, or papier-mâché.

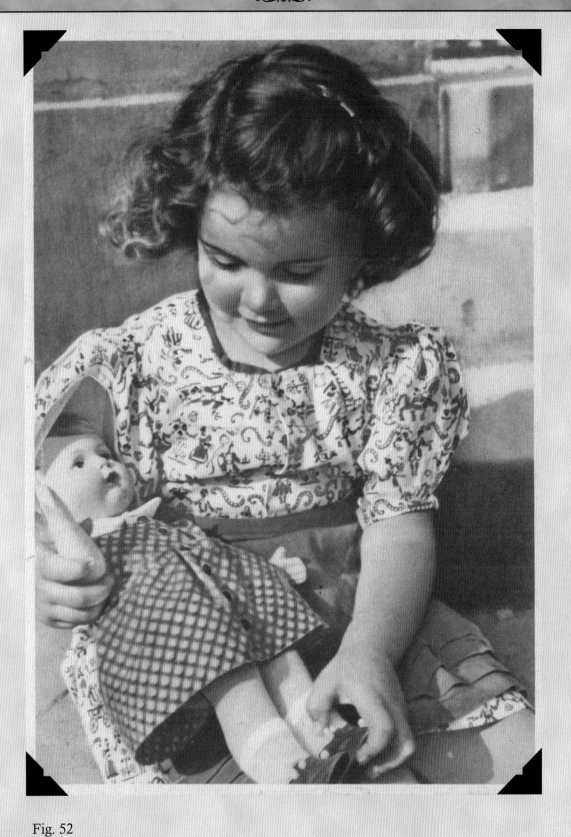

Fig. 52
4in x 5¾in (10cm x 15cm)
A young girl admires her character doll in this photomechanical halftone postcard circa 1940. The dots in this image are in full color, rather than the black and white dots of Fig. 51. *Jim and Janet Doud Collection.*

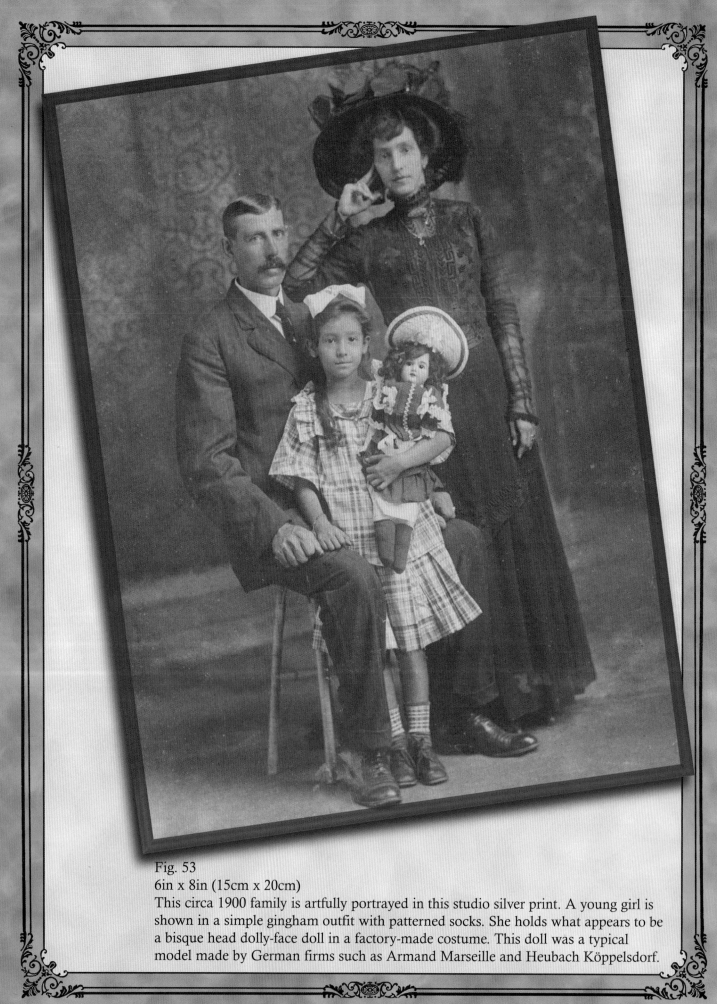

Fig. 53
6in x 8in (15cm x 20cm)
This circa 1900 family is artfully portrayed in this studio silver print. A young girl is shown in a simple gingham outfit with patterned socks. She holds what appears to be a bisque head dolly-face doll in a factory-made costume. This doll was a typical model made by German firms such as Armand Marseille and Heubach Köppelsdorf.

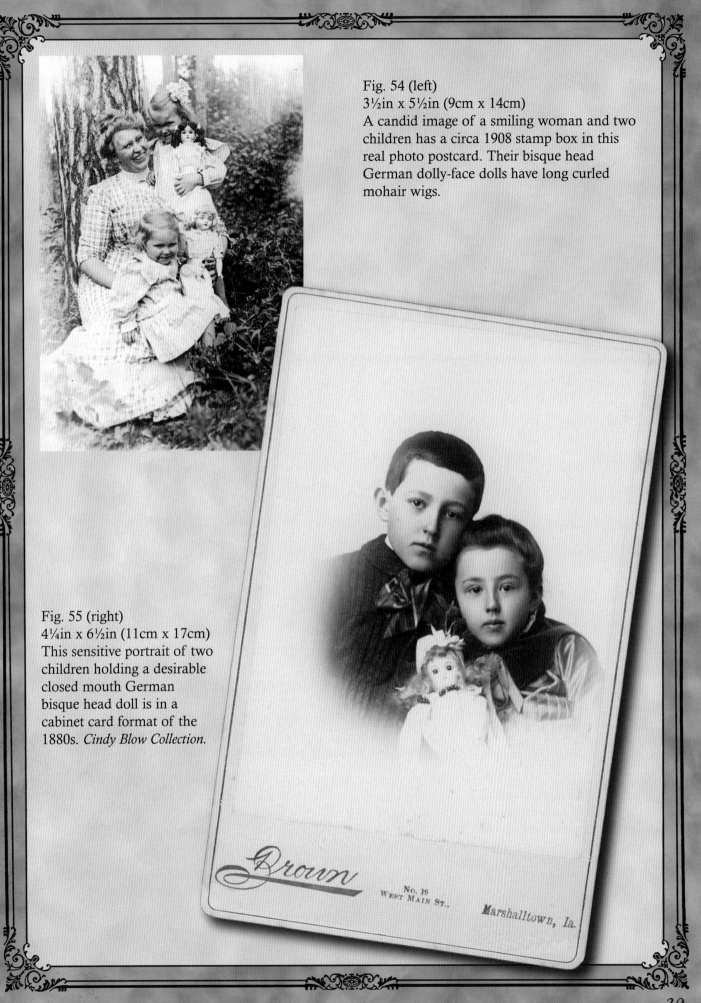

Fig. 54 (left)
3½in x 5½in (9cm x 14cm)
A candid image of a smiling woman and two children has a circa 1908 stamp box in this real photo postcard. Their bisque head German dolly-face dolls have long curled mohair wigs.

Fig. 55 (right)
4¼in x 6½in (11cm x 17cm)
This sensitive portrait of two children holding a desirable closed mouth German bisque head doll is in a cabinet card format of the 1880s. *Cindy Blow Collection.*

Brown
No. 19
WEST MAIN ST.,
Marshalltown, Ia.

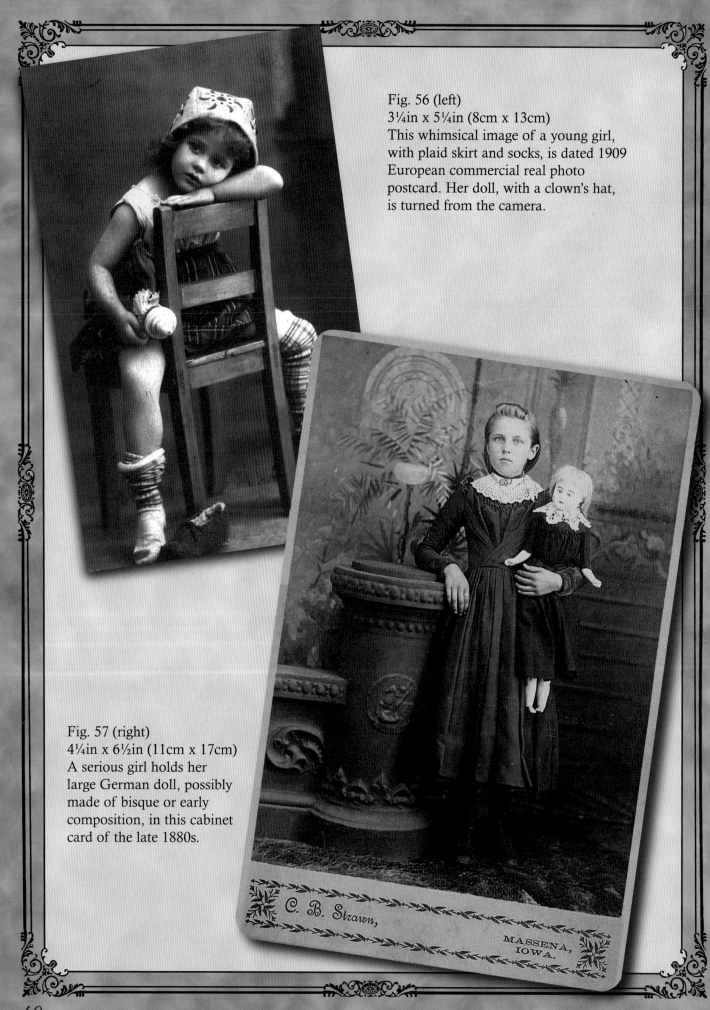

Fig. 56 (left)
3¼in x 5¼in (8cm x 13cm)
This whimsical image of a young girl,
with plaid skirt and socks, is dated 1909
European commercial real photo
postcard. Her doll, with a clown's hat,
is turned from the camera.

Fig. 57 (right)
4¼in x 6½in (11cm x 17cm)
A serious girl holds her
large German doll, possibly
made of bisque or early
composition, in this cabinet
card of the late 1880s.

C. B. Strawn,

MASSENA,
IOWA.

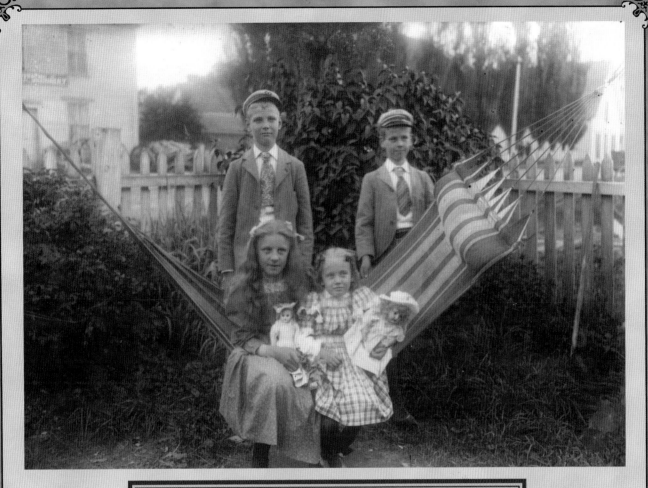

Heartsease in my garden bed
With sweet william white and red
Honeysuckle on my wall: —
Heartsease blossoms in my heart
When sweet William comes to call,
But it withers when we part,
And the honey-trumpets fall.

Christina Rossetti
Sing-Song

Fig. 58 (above)
6¾in x 5¾in (17cm x 15cm)
This charming silver print of the 1890s shows two bisque head dolls in an overgrown garden scene. The stylishly dressed doll on the right resembles models made by Jumeau in France, while the doll on the left has German origins.

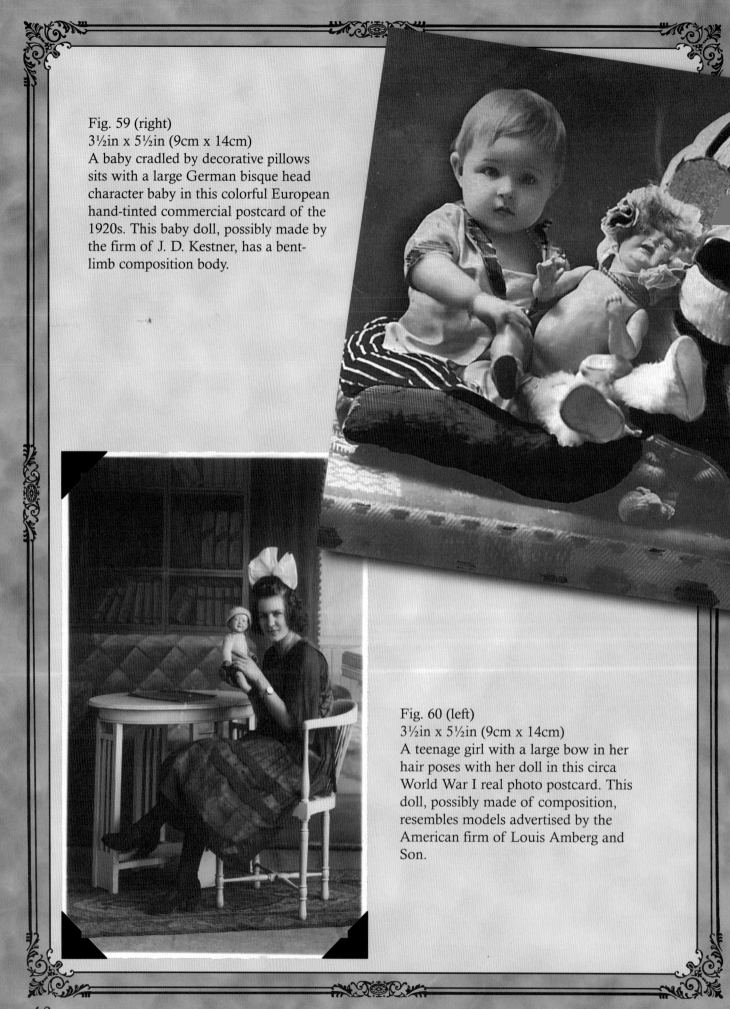

Fig. 59 (right)
3½in x 5½in (9cm x 14cm)
A baby cradled by decorative pillows sits with a large German bisque head character baby in this colorful European hand-tinted commercial postcard of the 1920s. This baby doll, possibly made by the firm of J. D. Kestner, has a bent-limb composition body.

Fig. 60 (left)
3½in x 5½in (9cm x 14cm)
A teenage girl with a large bow in her hair poses with her doll in this circa World War I real photo postcard. This doll, possibly made of composition, resembles models advertised by the American firm of Louis Amberg and Son.

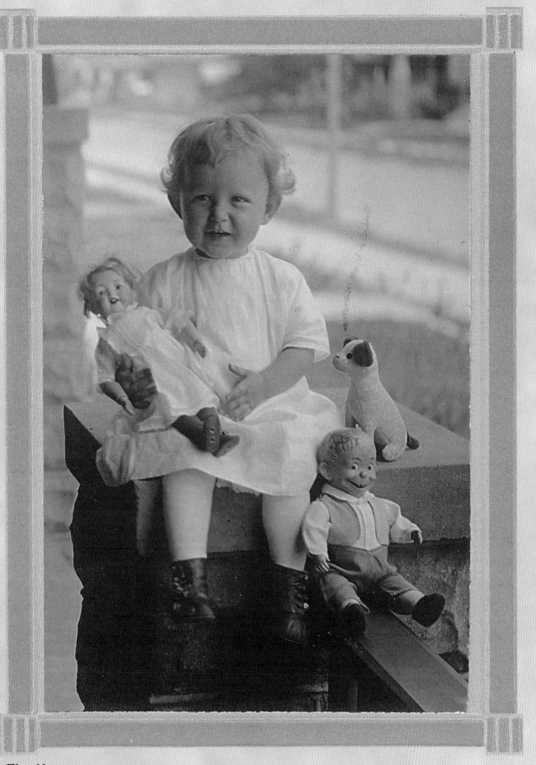

Fig. 61
3¼in x 4in (8cm x 10cm)
A toddler sits on a stone porch pedestal holding her German bisque head character doll with unusual feet in this silver print. Next to her stuffed plush puppy sits an American composition doll that appears to be a "Gene Carr Kid" named "Mike." "Mike" was a cartoon character created by Bernard Lipfert and was produced in doll form by Horseman around 1915.

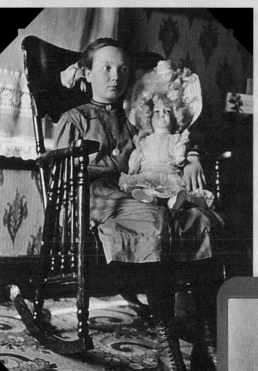

Fig. 62 (left)
3½in x 5½in (9cm x 14cm)
In this real photo postcard dated 1911, a young girl sits in a splendid rocker with fancy turned spindles. She holds a bisque head German dolly-face doll in an elaborate factory-made outfit.

Fig. 63 (right)
4¼in x 6½in (11cm x 17cm)
This cabinet card of the 1880s shows a child seated on a bale of hay while holding a china head doll with a common wavy lowbrow hairstyle. *Jim and Janet Doud Collection.*

Fig. 64 (left)
3¾in x 5¾in (10cm x 15cm)
As a baby plays with a clown doll, a girl watches at his side. This sensitive and artistic studio silver print portrait, circa 1915, is a very endearing pose not usually found in photographs of this period. *Jim and Janet Doud Collection.*

Fig. 65 (right)
3in x 5in (8cm x 13cm)
A young boy in this silver print clutches a composition and cloth doll that appears to be a "Campbell Kid" made by the E. I. Horseman Company in the United States around 1910. This doll was based on characters created by Grace G. Drayton for the Campbell Soup Company. *Jim and Janet Doud Collection.*

45

Fig. 66 (left)
5¼in x 7¼in (13cm x 19cm)
This dated 1927 silver print is of a young girl posing with her composition mama doll on Christmas day. The girl is dressed in a fur-trimmed velvet coat, hat, and wool leggings.

Fig. 67 (right)
3¼in x 5¼in (8cm x 13cm)
Two young girls pose with a Lenci-type doll, probably made of cloth, with a curly mohair wig. This European commercial real photo postcard was produced in the 1920s.

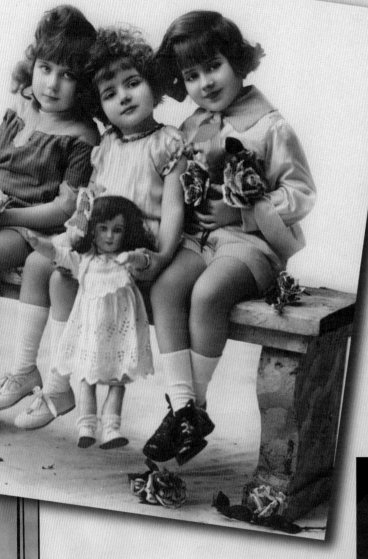

Fig. 68 (left)
3½in x 5½in (9cm x 14cm)
This French commercial real
photo postcard, postmarked 1925,
has been hand tinted. The pretty
bisque head doll has a ball-jointed
composition body.

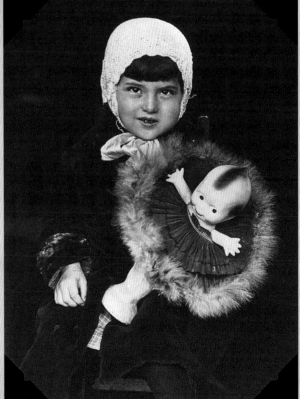

Fig. 69 (right)
3½in x 4¾in (9cm x 12cm)
The smiling chalkware carnival
"Kewpie" in this dated 1930 silver
print is dressed in a gathered crepe
paper skirt with swan's-down trim.
Dolls of this type were inspired by the
designs of Rose O'Neill and were
given as prizes at fairs and carnivals or
were sold through catalogs. *Jim and
Janet Doud Collection.*

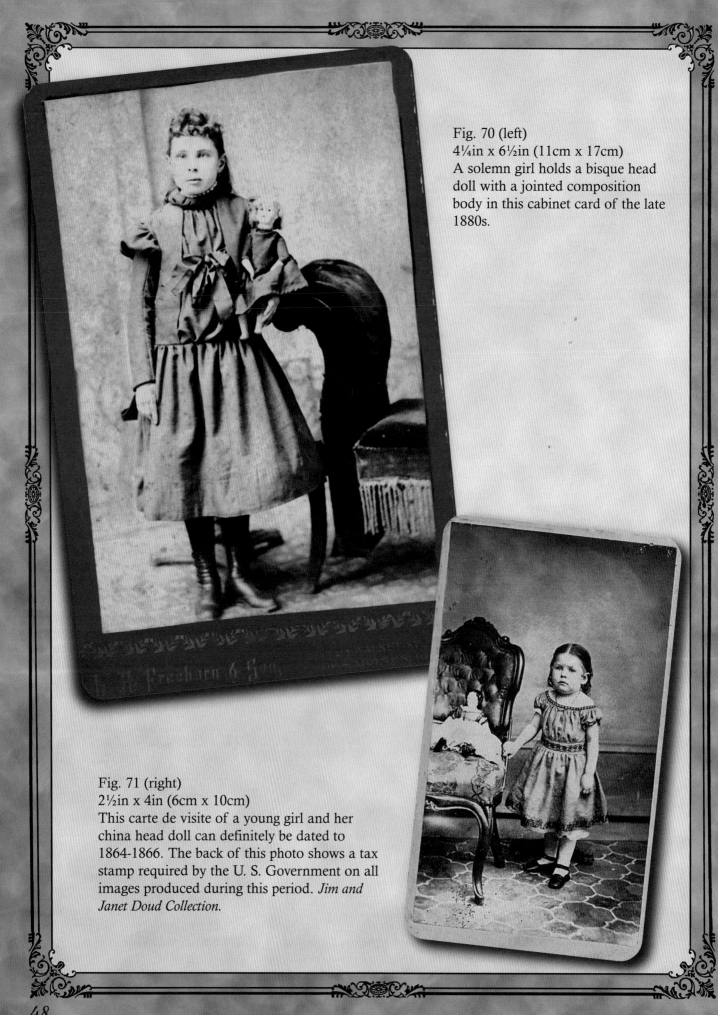

Fig. 70 (left)
4¼in x 6½in (11cm x 17cm)
A solemn girl holds a bisque head doll with a jointed composition body in this cabinet card of the late 1880s.

Fig. 71 (right)
2½in x 4in (6cm x 10cm)
This carte de visite of a young girl and her china head doll can definitely be dated to 1864-1866. The back of this photo shows a tax stamp required by the U. S. Government on all images produced during this period. *Jim and Janet Doud Collection.*

Fig. 72 (below)
3½in x 4½in (9cm x 12cm)
This snapshot shows a young girl carefully grooming her doll, probably made of composition with a human hair wig. Various American firms such Arranbee, Alexander, Horseman, and Ideal made dolls of this type during the 1940s.

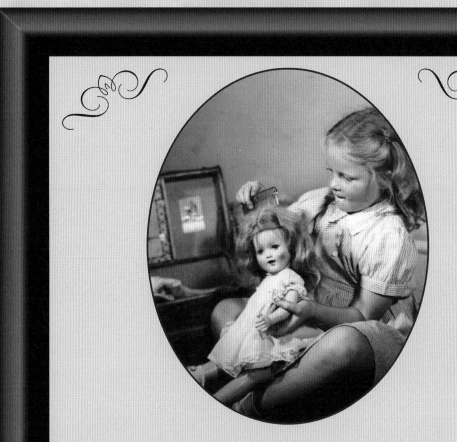

...It is not to tease you and hurt you, my sweet,
But only for kindness and care,
That I wash you, and dress you, and make you
 look neat,
And comb out your tanglesome hair.

From
"Washing and Dressing"
Jane and Ann Taylor
Little Ann and Other Poems

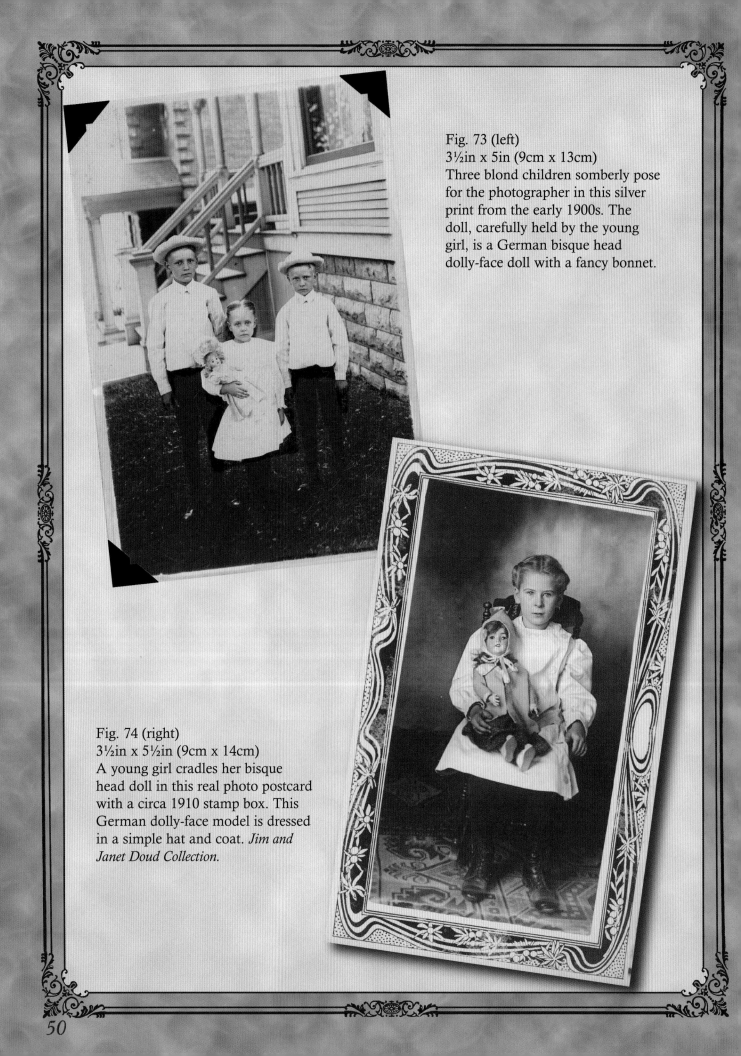

Fig. 73 (left)
3½in x 5in (9cm x 13cm)
Three blond children somberly pose for the photographer in this silver print from the early 1900s. The doll, carefully held by the young girl, is a German bisque head dolly-face doll with a fancy bonnet.

Fig. 74 (right)
3½in x 5½in (9cm x 14cm)
A young girl cradles her bisque head doll in this real photo postcard with a circa 1910 stamp box. This German dolly-face model is dressed in a simple hat and coat. *Jim and Janet Doud Collection.*

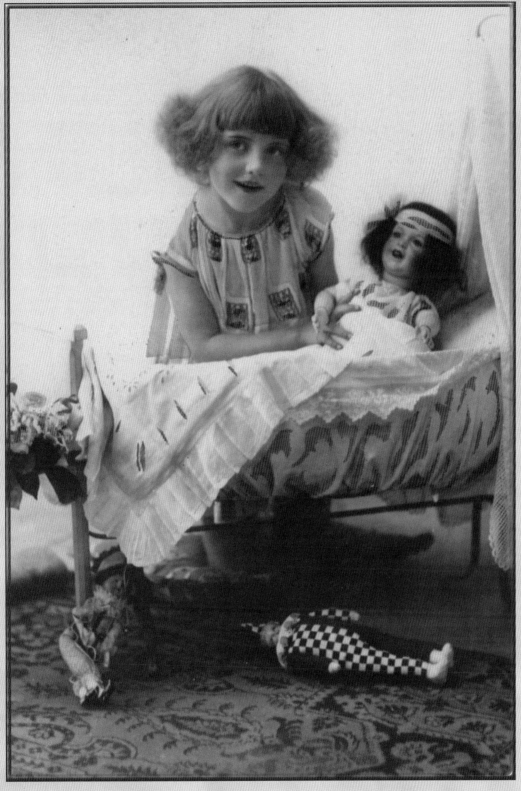

Fig. 75
3½in x 5½in (9cm x 14cm)
This French hand-tinted commercial real photo postcard is a colorful image of a girl and her bisque head character doll. This realistic model strongly resembles a doll made in France by the S.F.B.J. firm (Société Française de Fabrication de Bébés & Jouets) circa 1920.

51

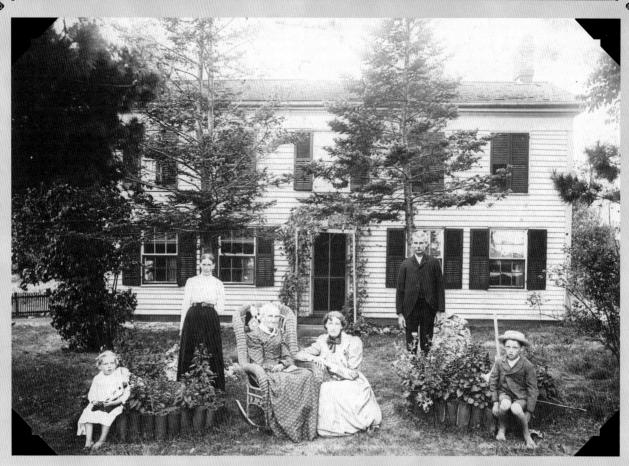

Fig. 76 (above)
7in x 4¾in (18cm x 12cm)
The photographer of this large albumen print has recorded the image of a family in front of their shuttered two-story home. The young girl cradles a china head doll while the boy at right wears a straw hat in this circa 1900 image.

Fig. 77 (right)
3½in x 5½in (9cm x 14cm)
This candid real photo postcard image, with a 1910 stamp box, shows three boys with wide-brimmed straw hats. The two girls each hold a doll.

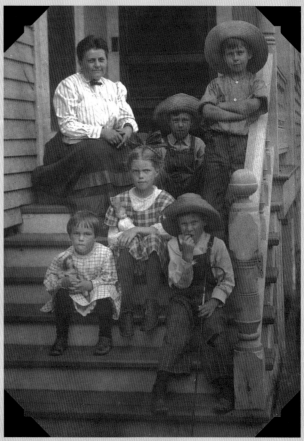

Fig. 78 (right)
2in x 2¾in (5cm x 7cm)
A rare wax-over papier-mâché composition lady doll, with an unusual molded hat, is pictured in this cased tintype from the late 1860s. The doll's feet are carved from wood and painted.

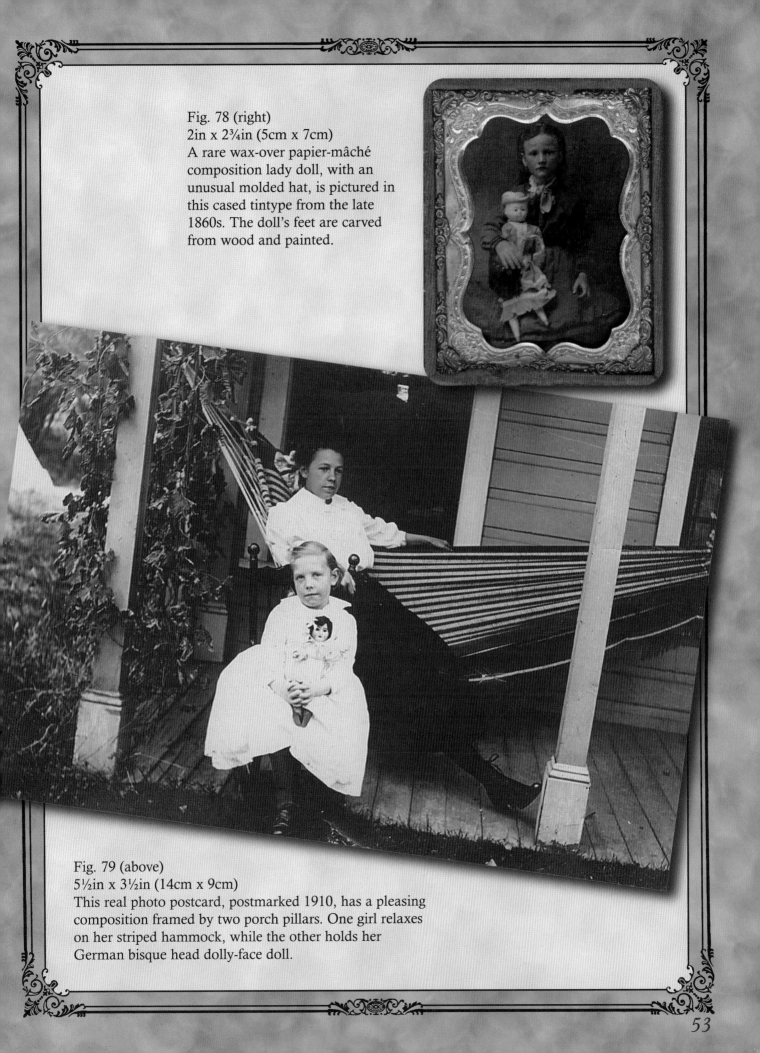

Fig. 79 (above)
5½in x 3½in (14cm x 9cm)
This real photo postcard, postmarked 1910, has a pleasing composition framed by two porch pillars. One girl relaxes on her striped hammock, while the other holds her German bisque head dolly-face doll.

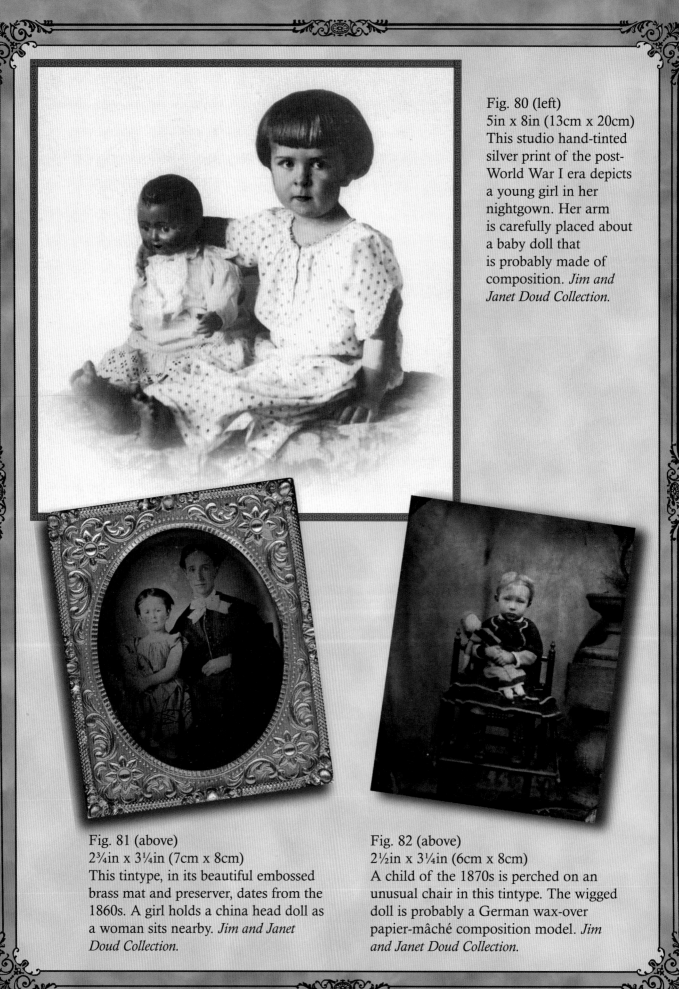

Fig. 80 (left)
5in x 8in (13cm x 20cm)
This studio hand-tinted silver print of the post-World War I era depicts a young girl in her nightgown. Her arm is carefully placed about a baby doll that is probably made of composition. *Jim and Janet Doud Collection.*

Fig. 81 (above)
$2\frac{3}{4}$in x $3\frac{1}{4}$in (7cm x 8cm)
This tintype, in its beautiful embossed brass mat and preserver, dates from the 1860s. A girl holds a china head doll as a woman sits nearby. *Jim and Janet Doud Collection.*

Fig. 82 (above)
$2\frac{1}{2}$in x $3\frac{1}{4}$in (6cm x 8cm)
A child of the 1870s is perched on an unusual chair in this tintype. The wigged doll is probably a German wax-over papier-mâché composition model. *Jim and Janet Doud Collection.*

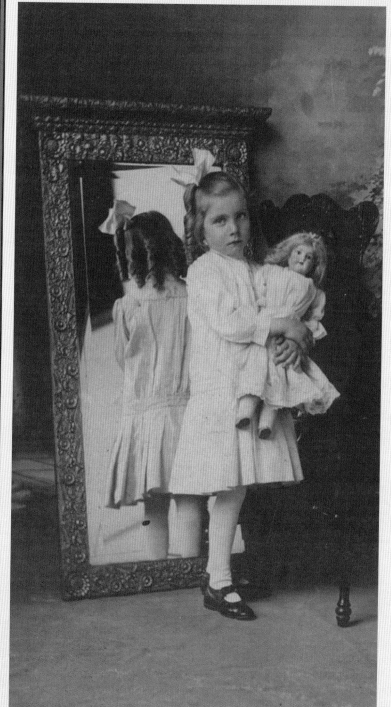

Monday's Child

Monday's child is
fair of face,
Tuesday's child is
full of grace,
Wednesday's child
is full of woe,
Thursday's child
has far to go,
Friday's child is
loving and giving,
Saturday's child
works hard for its
living,
But a child that's
born on the
Sabbath day
Is bonny and blithe,
and good and gay.

Mother Goose

Fig. 83
2½in x 4in (6cm x 10cm)
This circa 1910 studio silver print creatively uses a mirror as a very effective prop to showcase the beautiful curls of this young girl. She holds a bisque head German dolly-face doll.

55

Fig. 84 (left)
3½in x 5½in (9cm x 14cm)
The upholstered chair in this dated 1915 real photo postcard holds a bisque head dolly-face doll that closely resembles models made by Armand Marseille of Germany. Her ball-jointed body has awkward thin legs and small feet. However, the doll's hat and coat are skillfully hand crocheted.

Fig. 85 (below)
4½in x 2½in (12cm x 6cm)
The cozy setting before this circa 1915 craftsman style fireplace depicts a young girl holding a doll with a dark wig. Both woman and child are seated in wooden rockers in this silver print. On the mantel is a "Kewpie" doll, probably made of bisque, and designed by Rose O'Neill.

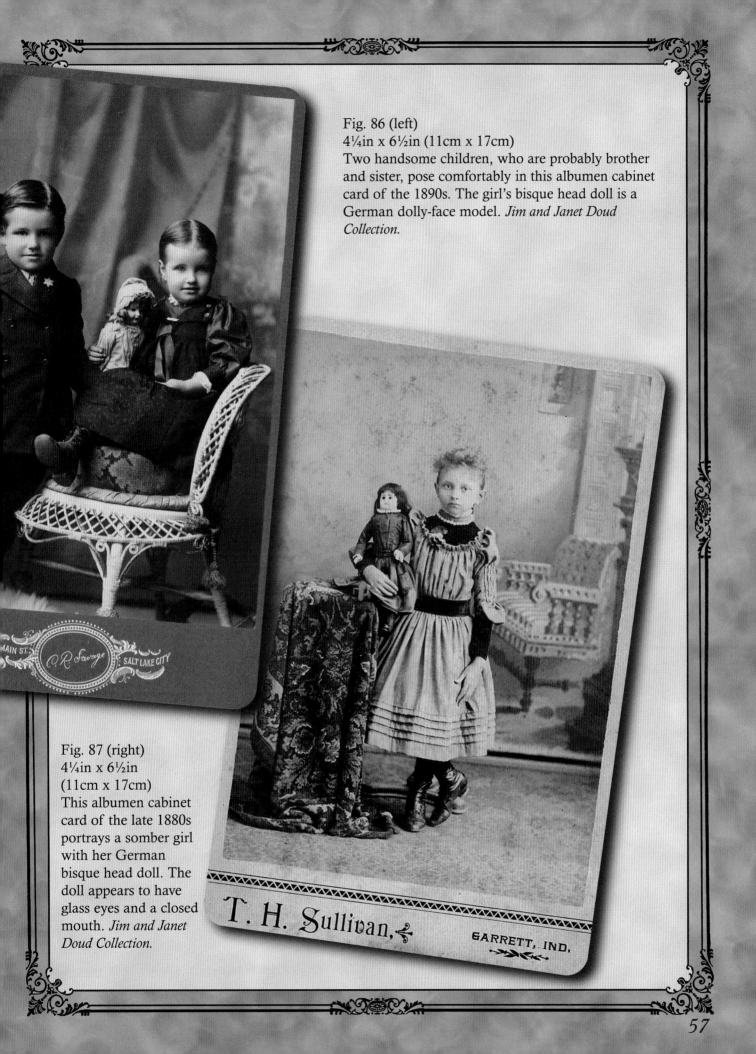

Fig. 86 (left)
4¼in x 6½in (11cm x 17cm)
Two handsome children, who are probably brother and sister, pose comfortably in this albumen cabinet card of the 1890s. The girl's bisque head doll is a German dolly-face model. *Jim and Janet Doud Collection.*

Fig. 87 (right)
4¼in x 6½in
(11cm x 17cm)
This albumen cabinet card of the late 1880s portrays a somber girl with her German bisque head doll. The doll appears to have glass eyes and a closed mouth. *Jim and Janet Doud Collection.*

C. R. Savage — MAIN ST. — SALT LAKE CITY

T. H. Sullivan, GARRETT, IND.

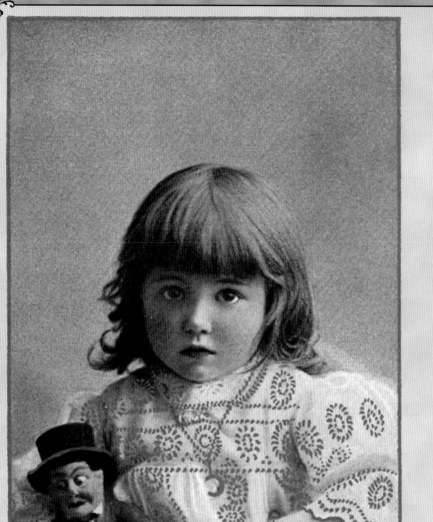

Fig. 88 (left)
$3\frac{1}{2}$in x $5\frac{1}{2}$in (9cm x 14cm)
The little girl holds an unusual character doll with a comic expression in this photomechanical halftone print. This image was produced in a color postcard format, circa 1910.

Fig. 89 (right)
$3\frac{1}{4}$in x $5\frac{1}{4}$in (8cm x 13cm)
A cloth doll in a patterned clown suit has hand-drawn features in this World War I era real photo postcard.

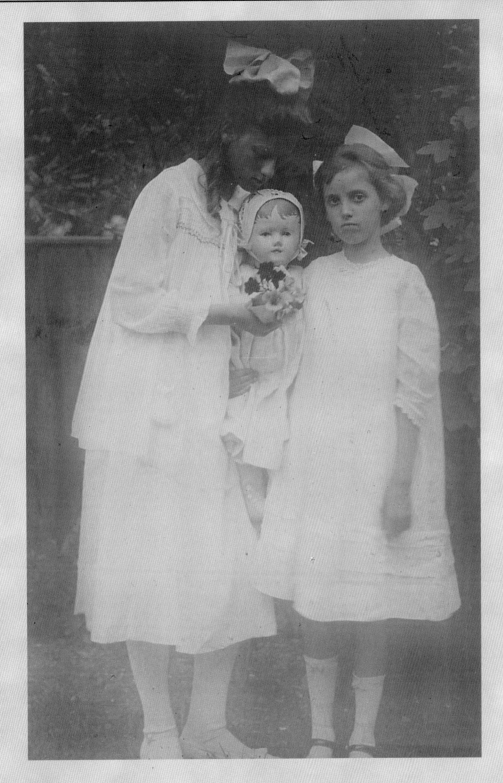

Fig. 90
4¼in x 6½in (11cm x 17cm)
This rare circa 1910 silver print depicts two girls holding a cloth doll with painted features. This model resembles the "Chase Stockinet Doll" designed by Martha Jenks Chase in the United States. The faded, misty quality of this photograph adds to its charm. *Jim and Janet Doud Collection.*

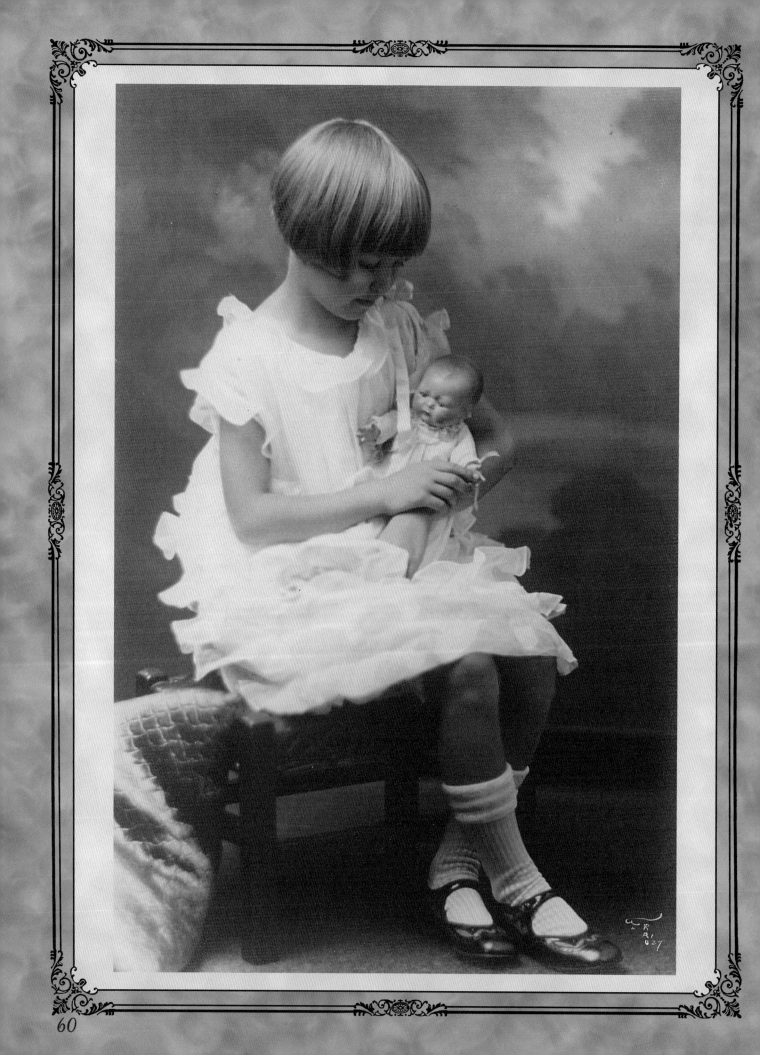

Fig. 91 (previous page)
6in x 9in (15cm x 23cm)
Virginia Ann, with her bobbed hair and ruffled dress, poses in this dated 1927 silver print. Her character doll is similar to "Tynie Baby" produced by Horsman in the United States in both bisque and composition models. *Virginia Uridel McMurray Collection.*

Fig. 92 (right)
3¼in x 5¼in (8cm x 13cm)
A boy and girl are dressed in identical sailor outfits in this real photo postcard with a circa 1915 stamp box. The bisque head dolly-face doll resembles models produced by J.D. Kestner of Germany. *Jim and Janet Doud Collection.*

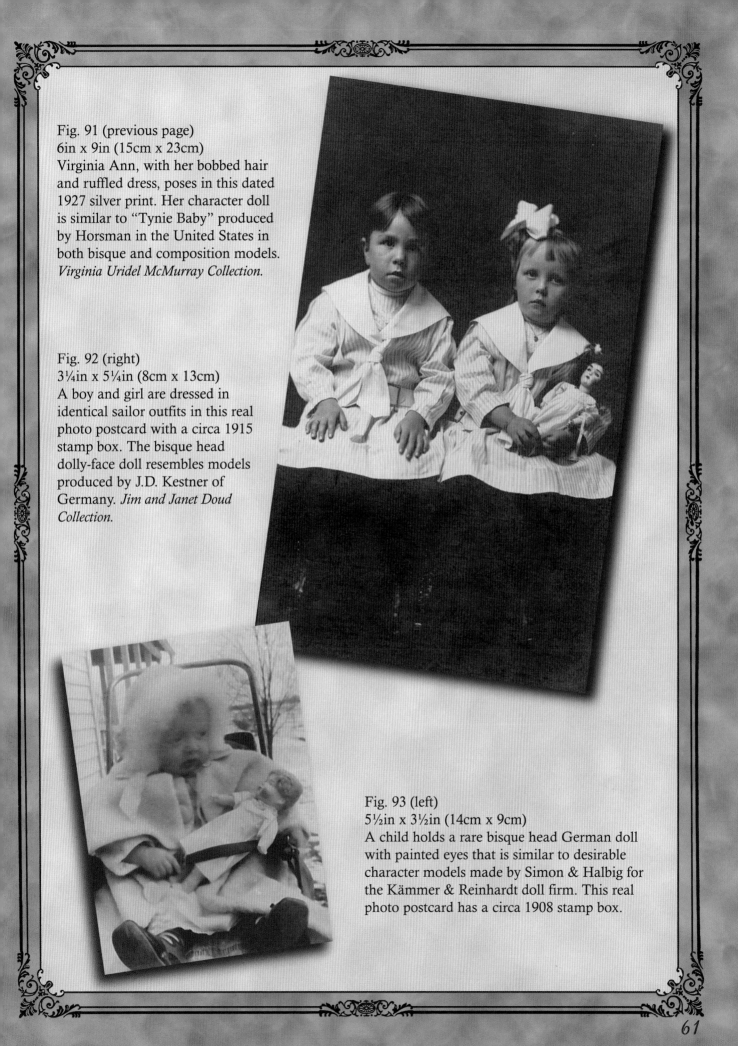

Fig. 93 (left)
5½in x 3½in (14cm x 9cm)
A child holds a rare bisque head German doll with painted eyes that is similar to desirable character models made by Simon & Halbig for the Kämmer & Reinhardt doll firm. This real photo postcard has a circa 1908 stamp box.

61

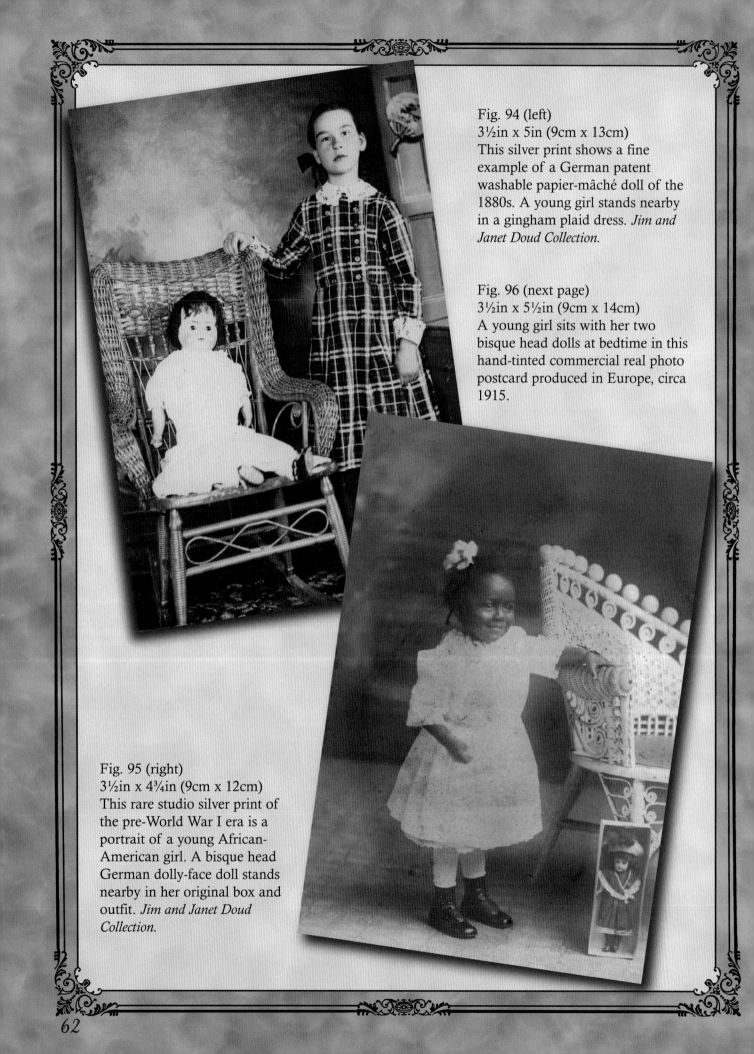

Fig. 94 (left)
3½in x 5in (9cm x 13cm)
This silver print shows a fine example of a German patent washable papier-mâché doll of the 1880s. A young girl stands nearby in a gingham plaid dress. *Jim and Janet Doud Collection.*

Fig. 96 (next page)
3½in x 5½in (9cm x 14cm)
A young girl sits with her two bisque head dolls at bedtime in this hand-tinted commercial real photo postcard produced in Europe, circa 1915.

Fig. 95 (right)
3½in x 4¾in (9cm x 12cm)
This rare studio silver print of the pre-World War I era is a portrait of a young African-American girl. A bisque head German dolly-face doll stands nearby in her original box and outfit. *Jim and Janet Doud Collection.*

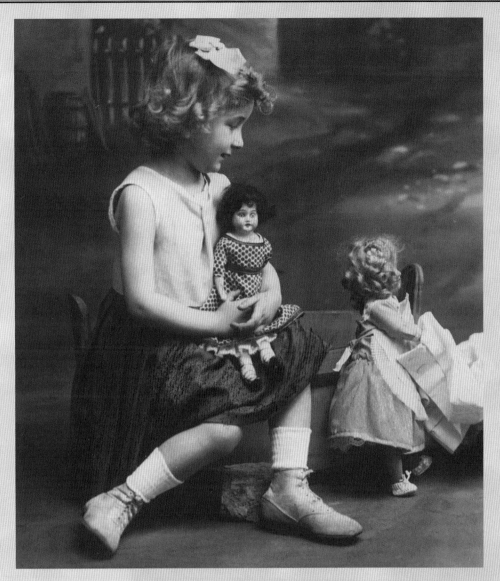

...And when I am tired I'll nestle my head
In the bosom that's soothed me so often,
And the wide-awake stars shall sing in my stead
A song which our dreaming shall soften.
So, Mother-My-Love, let me take your dear hand,
And away through the starlight we'll wander-
Away through the mist to the beautiful land-
The Dreamland that's waiting out yonder!

From
"Child and Mother"
Eugene Field
Poems of Childhood

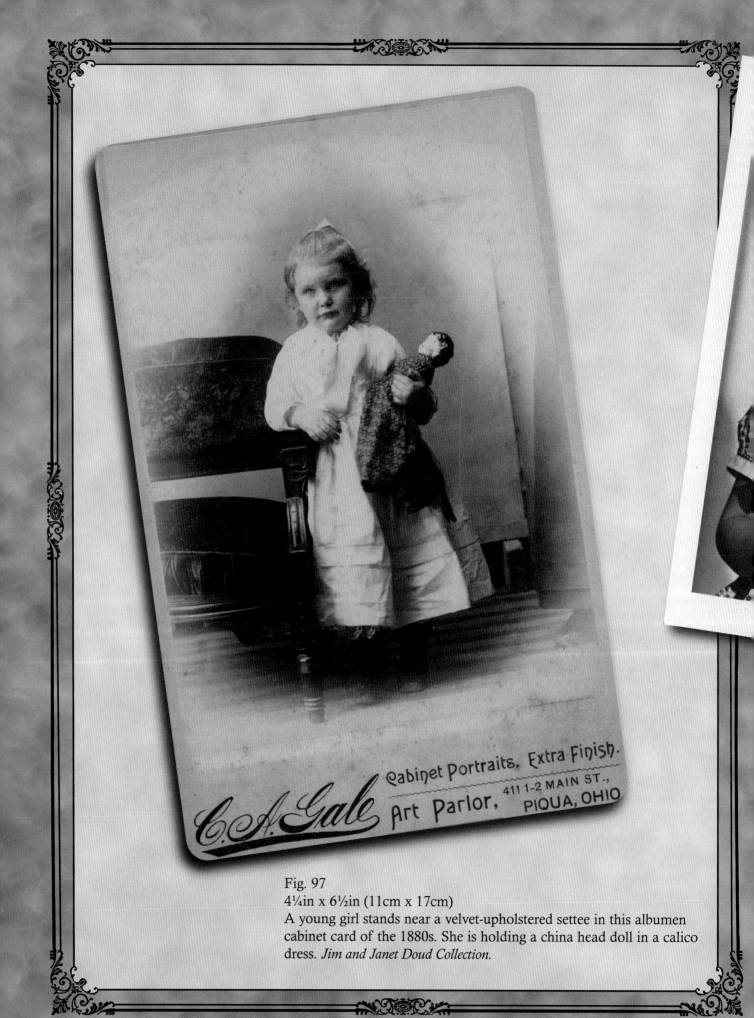

C.A. Gale

Cabinet Portraits, Extra Finish.

Art Parlor, 411 1-2 MAIN ST., PIQUA, OHIO

Fig. 97
4¼in x 6½in (11cm x 17cm)
A young girl stands near a velvet-upholstered settee in this albumen
cabinet card of the 1880s. She is holding a china head doll in a calico
dress. *Jim and Janet Doud Collection.*

Fig. 98 (left)
3½in x 4¾in (9cm x 12cm)
This young girl with satin hair bows and a smocked print dress holds a baby doll in this snapshot. The doll resembles "Babyette", a composition doll with a cloth body produced in 1946 by Effanbee, an American doll company.

Fig. 99 (right)
2¾in x 3¼in (7cm x 8cm)
A child holds an early bisque doll with a closed mouth in this tintype of the 1880s. The simple brass frame and preserver, although not original to the photograph, compliment the image.

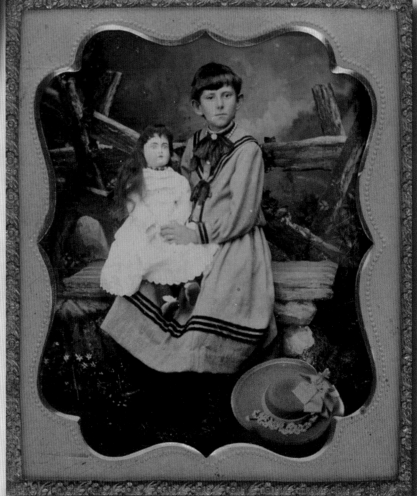

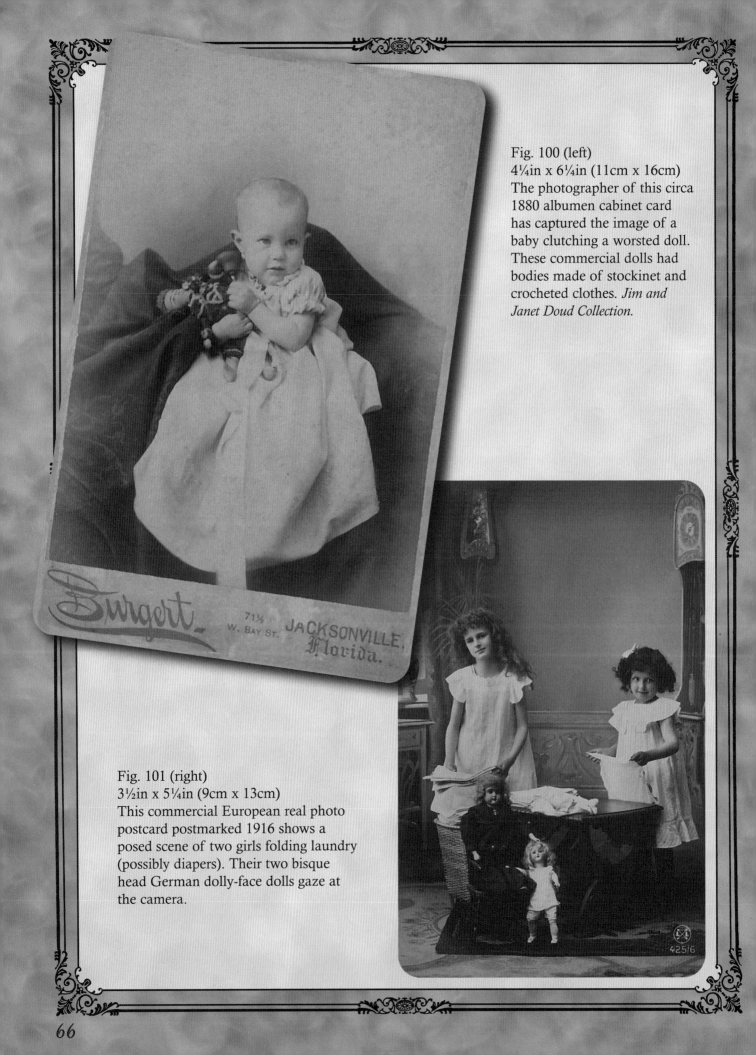

Fig. 100 (left)
4¼in x 6¼in (11cm x 16cm)
The photographer of this circa 1880 albumen cabinet card has captured the image of a baby clutching a worsted doll. These commercial dolls had bodies made of stockinet and crocheted clothes. *Jim and Janet Doud Collection.*

Burgert 71½ W. Bay St. JACKSONVILLE, Florida.

Fig. 101 (right)
3½in x 5¼in (9cm x 13cm)
This commercial European real photo postcard postmarked 1916 shows a posed scene of two girls folding laundry (possibly diapers). Their two bisque head German dolly-face dolls gaze at the camera.

66

Fig. 102
3½in x 5½in (9cm x 14cm)
A toddler dressed in a white eyelet dress holds a bisque head dolly-face doll dressed in a Welsh regional costume. Nearby, a barefoot baby sits with toes curled inward in this pre-World War I real photo postcard. *Anita Johnson Collection.*

Fig. 103 (left)
4in x 6½in (10cm x 17cm)
This studio silver print of the early 20th century is a memorable portrait of a girl holding a china head with a hairstyle from the 1860s. This doll has a center part and low sausage curls. *Jim and Janet Doud Collection.*

Fig. 104 (below)
5½in x 3½in (14cm x 9cm)
A boy smiles at the camera as he stands next to his bear and composition doll resembling "Buddy Lee" in this real photo postcard. This doll was manufactured by the H.D. Buddy Lee Merchantile Company to advertise overalls and work uniforms during the 1920s.

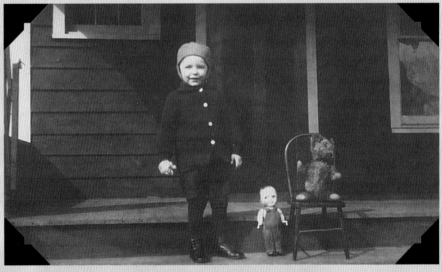

Fig. 105
3½in x 5½in (9cm x 14cm)
This unique tinted French commercial real photo postcard, with a 1907 postmark, portrays a girl kissing a marionette. This large puppet resembles "Polichenelle" (known as Punch in England) and is dressed in silk finery.

Fig. 106 (left)
4in x 6in (10cm x 15cm)
This studio silver print features a girl holding an excellent large bisque head character baby. Dolls similar to this model were made by German firms such as J.D. Kestner and Hertel Schwab & Company beginning in 1910. *Cindy Blow Collection.*

Fig. 108 (next page)
$5\frac{1}{2}$in x $3\frac{1}{2}$in (14cm x 9cm)
A girl with large hair bows and a scowling expression sits on a swing holding a glass-eyed doll with a molded hairstyle in this circa 1910 real photo postcard.

Fig. 107 (right)
$3\frac{1}{2}$in x $5\frac{1}{2}$in (9cm x 14cm)
A boy and girl happily pose on a artificial log with a bisque head German dolly-face doll. This real photo postcard has a stamp box date of circa 1915.

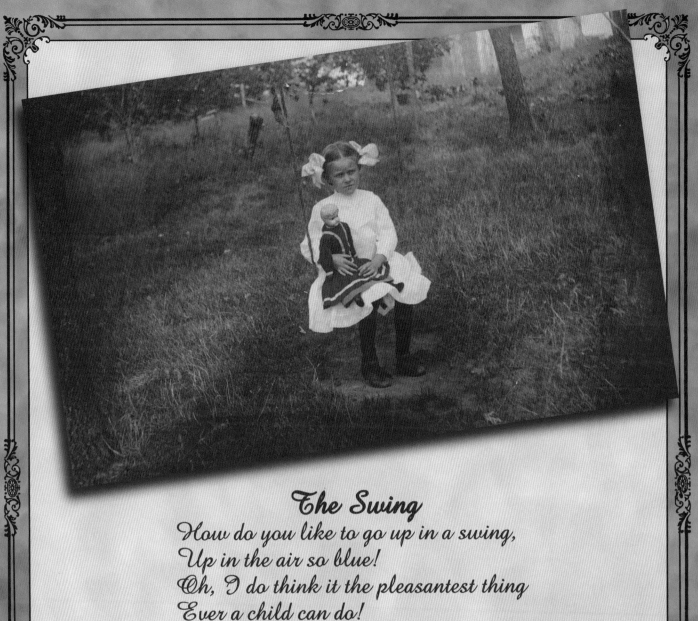

The Swing

How do you like to go up in a swing,
Up in the air so blue!
Oh, I do think it the pleasantest thing
Ever a child can do!

Up in the air and over the wall,
Till I can see so wide
Rivers and trees and cattle and all
Over the countryside—

Till I look down on the garden green,
Down on the roof so brown—
Up in the air I go flying again,
Up in the air and down!

Robert Louis Stevenson
A Child's Garden of Verses

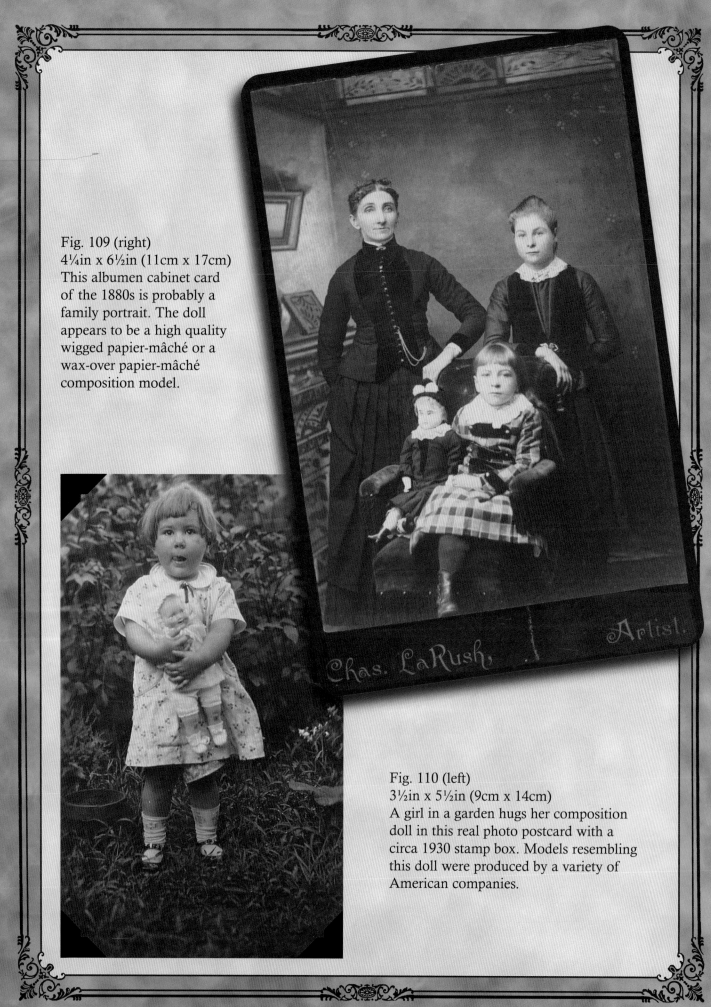

Fig. 109 (right)
4¼in x 6½in (11cm x 17cm)
This albumen cabinet card
of the 1880s is probably a
family portrait. The doll
appears to be a high quality
wigged papier-mâché or a
wax-over papier-mâché
composition model.

Chas. LaRush, Artist.

Fig. 110 (left)
3½in x 5½in (9cm x 14cm)
A girl in a garden hugs her composition
doll in this real photo postcard with a
circa 1930 stamp box. Models resembling
this doll were produced by a variety of
American companies.

Fig. 111 (left)
3½in x 5½in (9cm x 14cm)
A boy and girl seem pleased to pose for the camera in this real photo postcard with a 1907 stamp box. She is holding a worsted doll wearing an interesting crocheted outfit.

Fig. 112 (right)
3¼in x 5½in (8cm x 14cm)
This real photo postcard, with a circa 1920 stamp box, portrays a blond girl with a bisque head character baby. This wigged model is similar to dolls produced by German companies such as Simon & Halbig and J.D. Kestner. Her bent-limb baby body is made of composition.

73

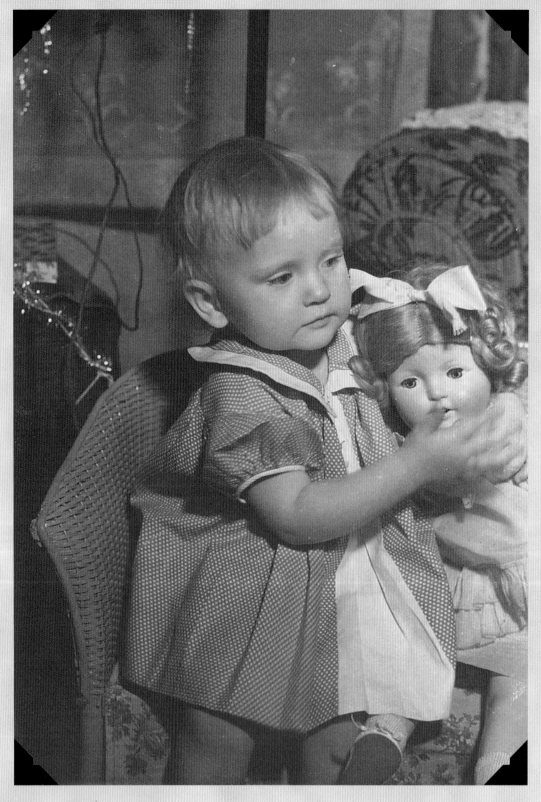

Fig. 113
4¾in x 6½in (12cm x 17cm)
A toddler girl in this silver print hugs her composition doll. This doll appears
to be a Shirley Temple-type doll made by an American company named
Horsman in the 1930s.

Fig. 114 (right)
$3\frac{1}{4}$in x $4\frac{1}{4}$in (8cm x 11cm)
The girl's delicate white eyelet dress, with lace-trimmed yoke and puffed sleeves, is a similar style of the dress worn by her doll. The bisque head German character doll in this circa 1910 studio silver print has a dark mohair or human hair wig.

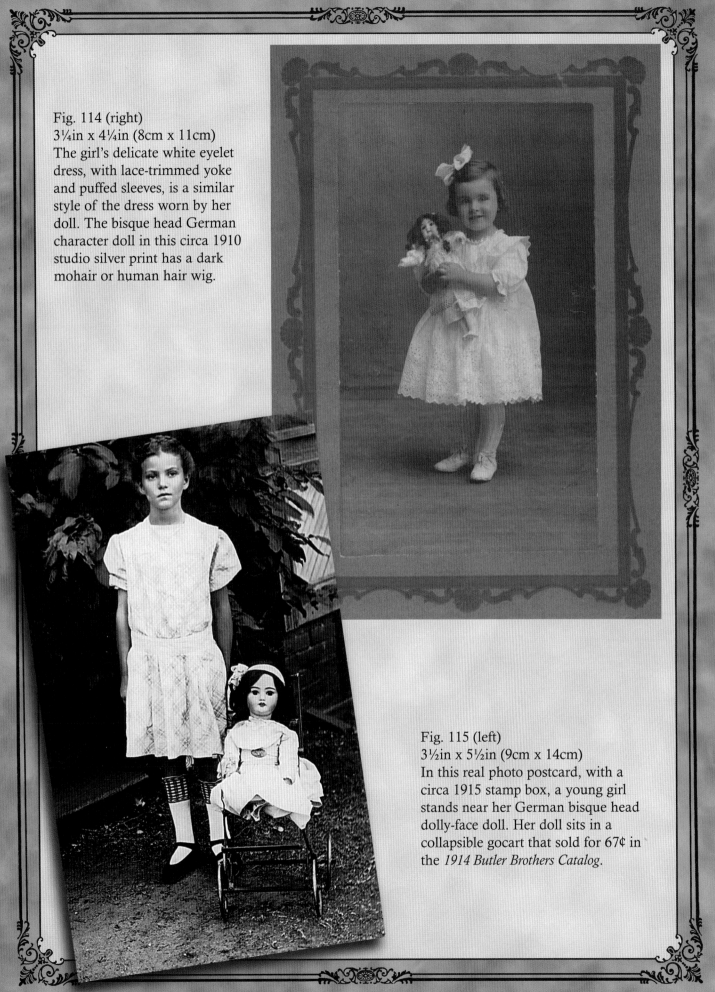

Fig. 115 (left)
$3\frac{1}{2}$in x $5\frac{1}{2}$in (9cm x 14cm)
In this real photo postcard, with a circa 1915 stamp box, a young girl stands near her German bisque head dolly-face doll. Her doll sits in a collapsible gocart that sold for 67¢ in the *1914 Butler Brothers Catalog*.

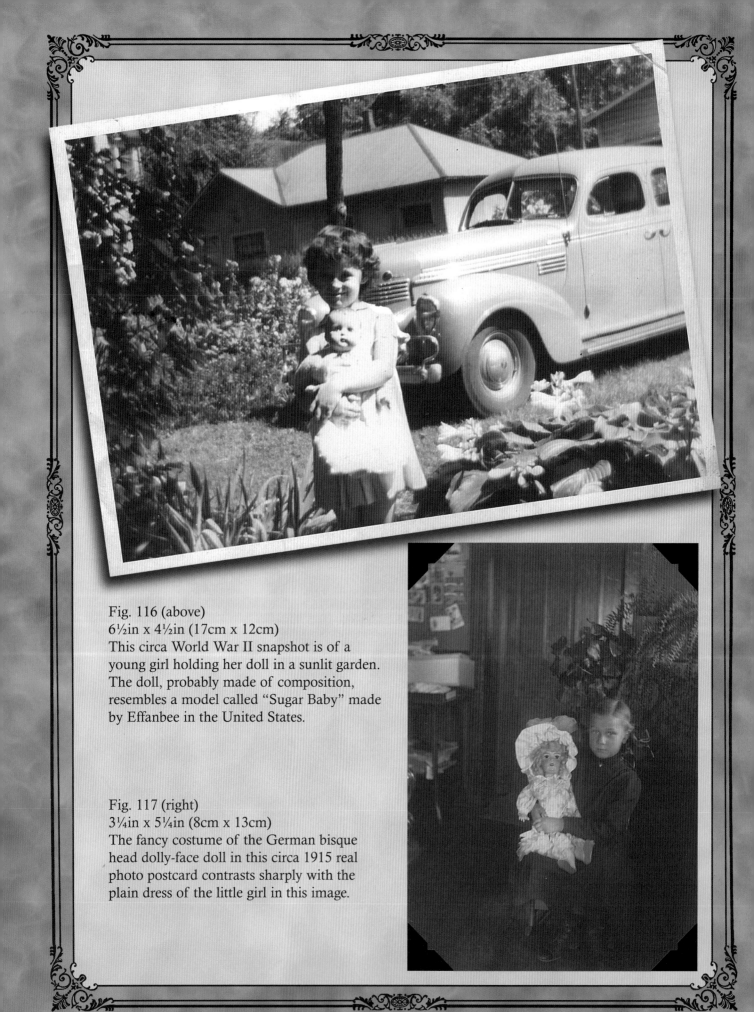

Fig. 116 (above)
6½in x 4½in (17cm x 12cm)
This circa World War II snapshot is of a
young girl holding her doll in a sunlit garden.
The doll, probably made of composition,
resembles a model called "Sugar Baby" made
by Effanbee in the United States.

Fig. 117 (right)
3¼in x 5¼in (8cm x 13cm)
The fancy costume of the German bisque
head dolly-face doll in this circa 1915 real
photo postcard contrasts sharply with the
plain dress of the little girl in this image.

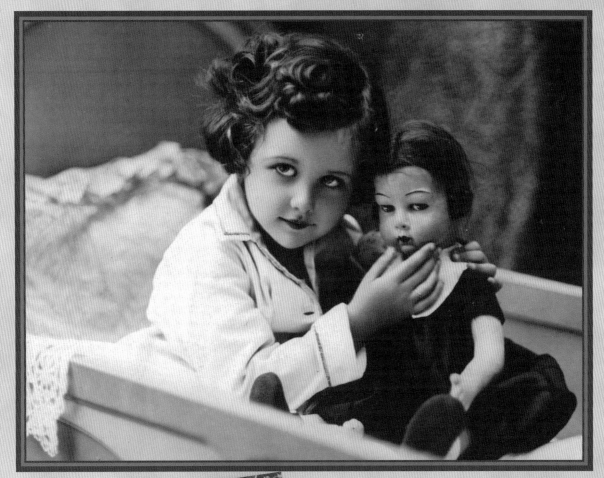

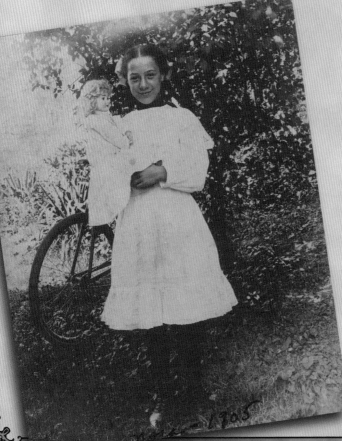

Fig. 118 (above)
5½in x 3½in (13cm x 9cm)
The tender scene in this circa 1920s
French commercial real photo postcard
portrays a young girl with a cloth doll
very similar to felt models with side
glancing eyes made by Lenci, an Italian
doll firm.

Fig. 119 (left)
3¾in x 4¾in (10cm x 12cm)
In this dated 1905 silver print, a girl
smiles contentedly for the camera as she
holds her blond bisque head doll made
in Germany. *Jim and Janet Doud Collection.*

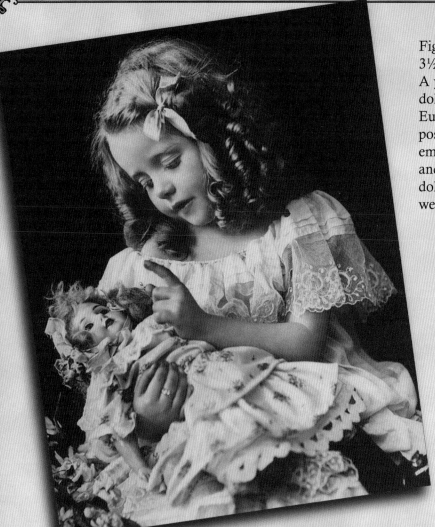

Fig. 120
3½in x 5½in (9cm x 14cm)
A young girl admonishes her doll in this commercial European real photo postcard, circa 1910. The lace embellished dresses of the girl and her German bisque head doll are typical of those worn by wealthy children of this era.

The Judge

Say of him what you please, but I know my child's failings.
I do not love him because he is good, but because he is my little child.
How should you know how dear he can be when you try to weigh his
 merits against his faults?
When I must punish him he becomes all the more a part of my being.
When I cause his tears to come my heart weeps with him.
I alone have a right to blame and punish, for he only may chastise
 who loves.

Rabindranath Tagore
The Crescent Moon

78

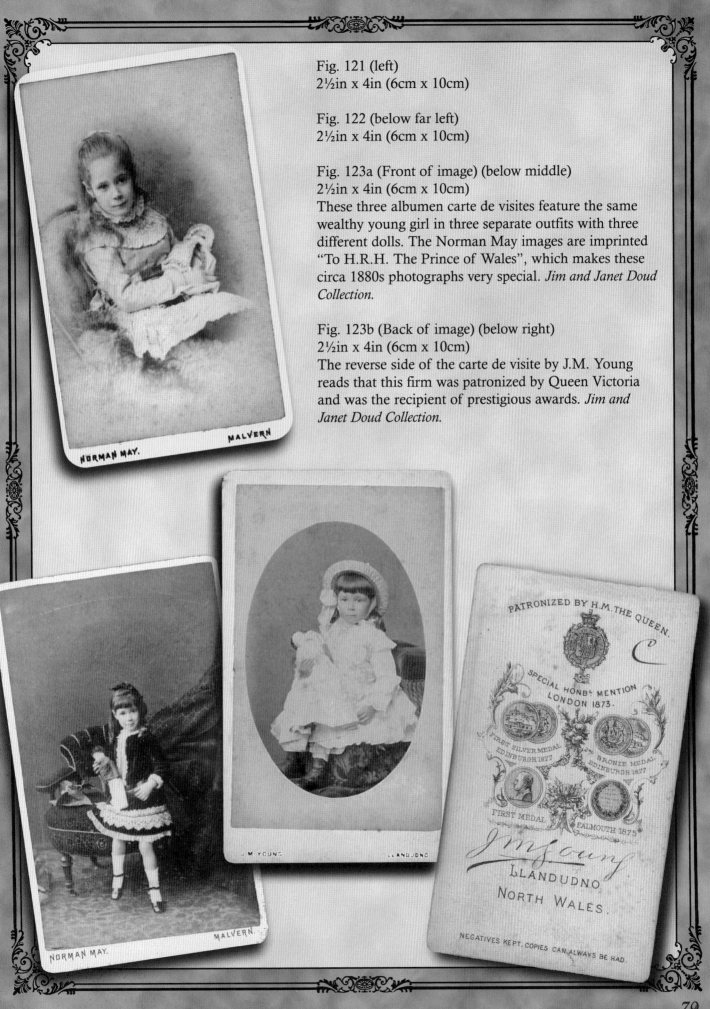

Fig. 121 (left)
2½in x 4in (6cm x 10cm)

Fig. 122 (below far left)
2½in x 4in (6cm x 10cm)

Fig. 123a (Front of image) (below middle)
2½in x 4in (6cm x 10cm)
These three albumen carte de visites feature the same wealthy young girl in three separate outfits with three different dolls. The Norman May images are imprinted "To H.R.H. The Prince of Wales", which makes these circa 1880s photographs very special. *Jim and Janet Doud Collection.*

Fig. 123b (Back of image) (below right)
2½in x 4in (6cm x 10cm)
The reverse side of the carte de visite by J.M. Young reads that this firm was patronized by Queen Victoria and was the recipient of prestigious awards. *Jim and Janet Doud Collection.*

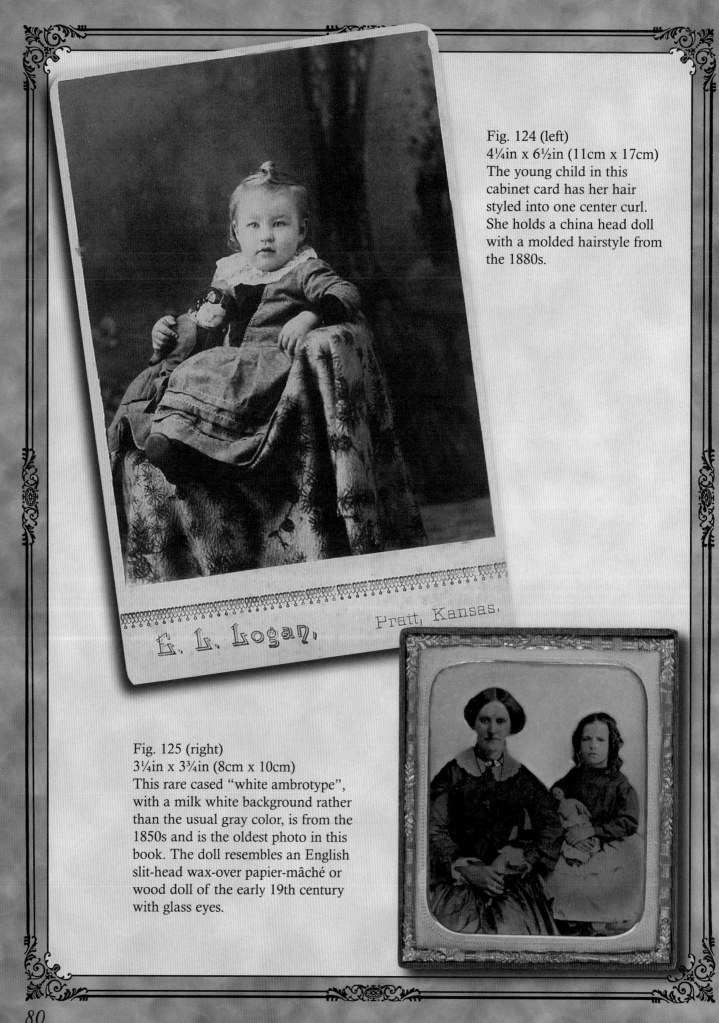

Fig. 124 (left)
4¼in x 6½in (11cm x 17cm)
The young child in this cabinet card has her hair styled into one center curl. She holds a china head doll with a molded hairstyle from the 1880s.

E. L. Logan, Pratt, Kansas,

Fig. 125 (right)
3¼in x 3¾in (8cm x 10cm)
This rare cased "white ambrotype", with a milk white background rather than the usual gray color, is from the 1850s and is the oldest photo in this book. The doll resembles an English slit-head wax-over papier-mâché or wood doll of the early 19th century with glass eyes.

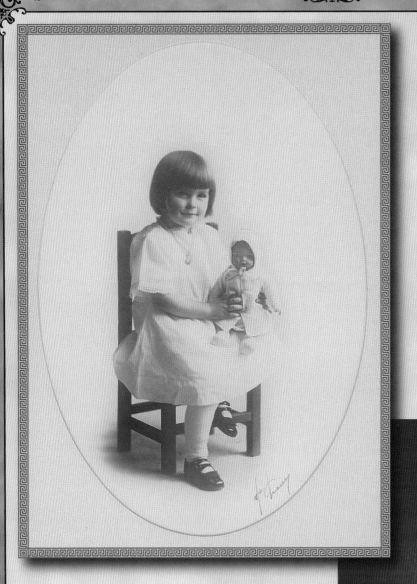

Fig. 126 (left)
5½in x 7½in (14cm x 19cm)
A young girl with a gentle smile holds a baby doll on her lap in this World War I era studio silver print. Composition dolls similar to this model were produced by various American firms such as the Averill Manufacturing Company and the E. F. Horsman Company. *Rosemary Beach Collection.*

Fig. 127 (right)
3¼in x 5¼in (8cm x 13cm)
In this European real photo postcard, circa 1910, a girl in a simple dress holds her German bisque head dolly-face doll with a jointed composition body.

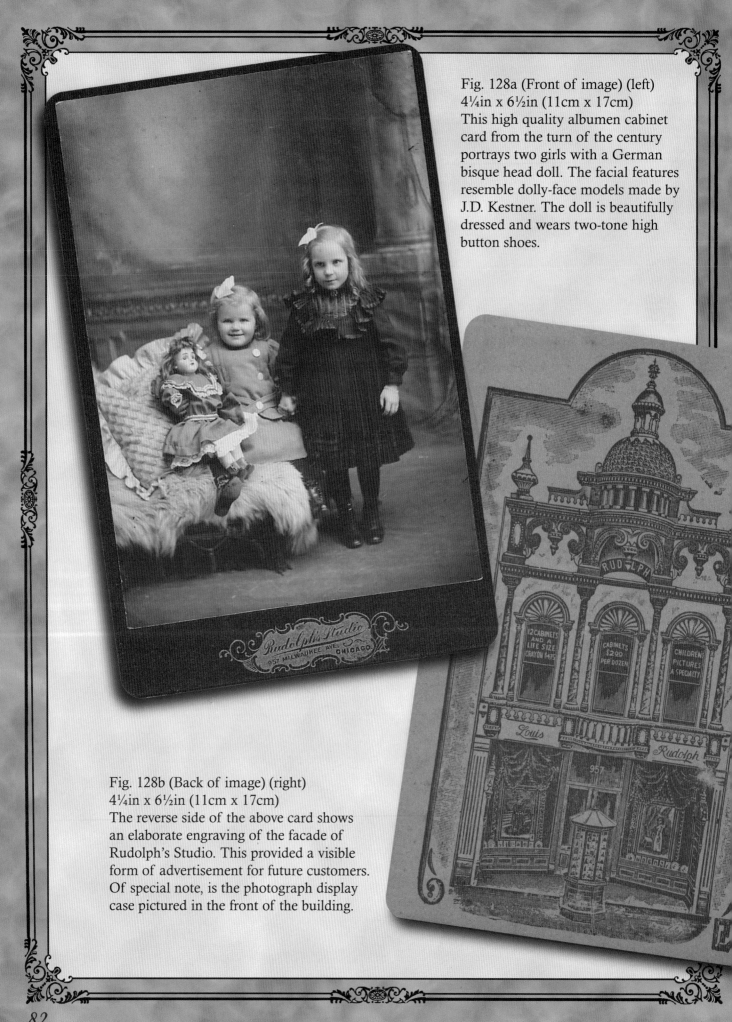

Fig. 128a (Front of image) (left)
$4\frac{1}{4}$in x $6\frac{1}{2}$in (11cm x 17cm)
This high quality albumen cabinet card from the turn of the century portrays two girls with a German bisque head doll. The facial features resemble dolly-face models made by J.D. Kestner. The doll is beautifully dressed and wears two-tone high button shoes.

Fig. 128b (Back of image) (right)
$4\frac{1}{4}$in x $6\frac{1}{2}$in (11cm x 17cm)
The reverse side of the above card shows an elaborate engraving of the facade of Rudolph's Studio. This provided a visible form of advertisement for future customers. Of special note, is the photograph display case pictured in the front of the building.

82

Fig. 129 (left)
7in x 3½in (18cm x 9cm)
With the caption "But when Sunday comes,
I say, Lie still, I'm going to Church with
Brother," this albumen stereograph image is
dated 1901. Of special note is the black doll
on a swing.

Fig. 130 (right)
3½in x 5¼in (9cm x 13cm)
A girl serenely poses for the
camera with her German
bisque head dolly-face doll in
this World War I era real
photo postcard. Both girl and
doll have dresses of the same
style and both have hair
bows. *Jim and Janet Doud
Collection.*

83

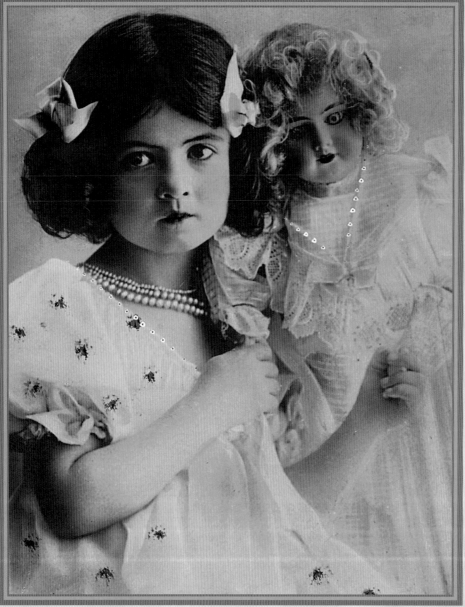

Fig. 131 (above)
3½in x 5½in (9cm x 14cm)
This delicately hand-tinted commercial real photo postcard, from the World War I era, features a young girl with her bisque head doll. This doll, with her luminous blown glass eyes, resembles dolly-face models made by Armand Marseille of Germany.

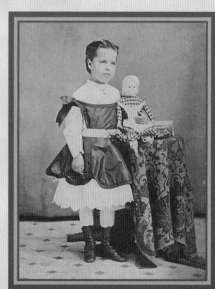

Fig. 132 (right)
2½in x 4in (6cm x 10cm)
A child has a wax-over papier-mâché composition doll with blond molded hair in this carte de visite dated 1869. Her painted limbs are probably carved from wood.

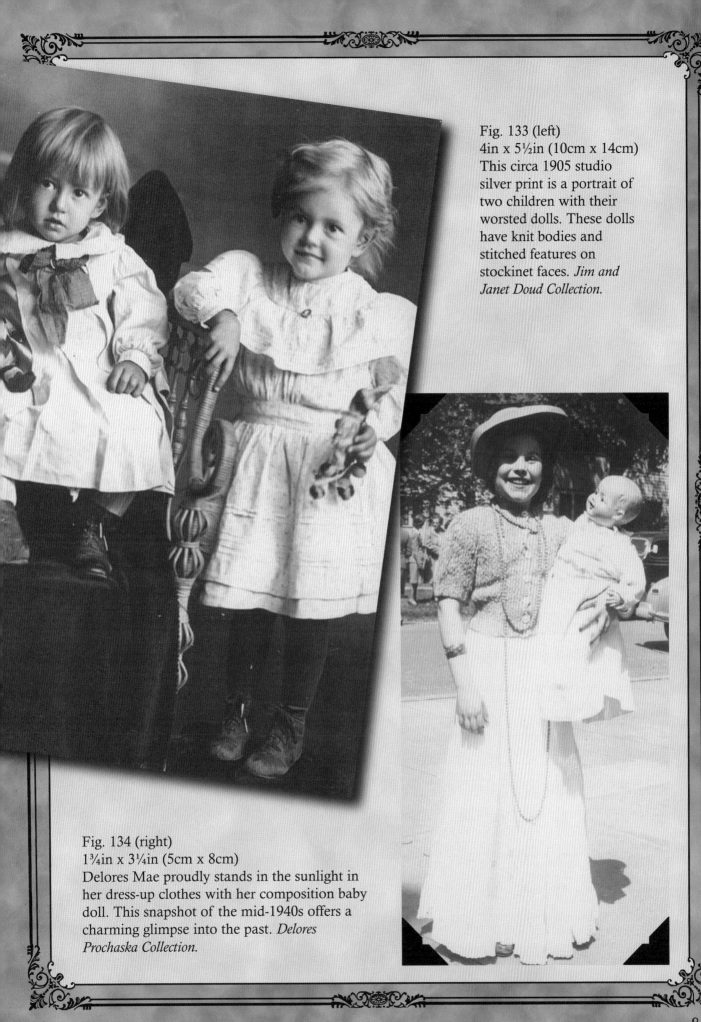

Fig. 133 (left)
4in x 5½in (10cm x 14cm)
This circa 1905 studio silver print is a portrait of two children with their worsted dolls. These dolls have knit bodies and stitched features on stockinet faces. *Jim and Janet Doud Collection.*

Fig. 134 (right)
1¾in x 3¼in (5cm x 8cm)
Delores Mae proudly stands in the sunlight in her dress-up clothes with her composition baby doll. This snapshot of the mid-1940s offers a charming glimpse into the past. *Delores Prochaska Collection.*

85

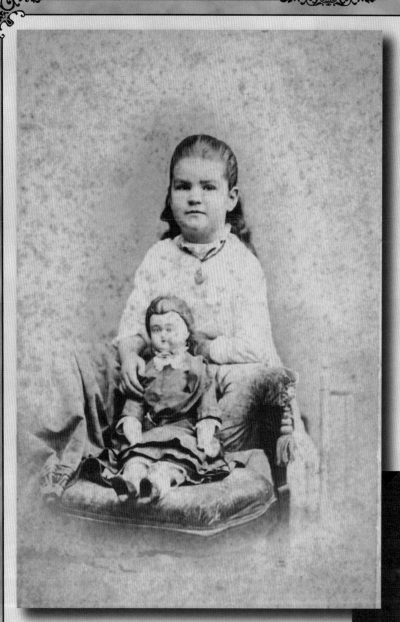

Fig. 135 (left)
4¼in x 6¼in (11cm x 16cm)
This albumen cabinet card of the 1870s is an exceptional image of a probable wigged wax-over papier-mâché composition doll of high quality. She has blown glass eyes and composition limbs with painted boots. *Jim and Janet Doud Collection.*

Fig. 136 (right)
3¼in x 5¼in (8cm x 13cm)
A happy child stands with her much-loved cloth doll in this real photo postcard with a 1920s stamp box. This doll might have been a homemade gift from a family member.

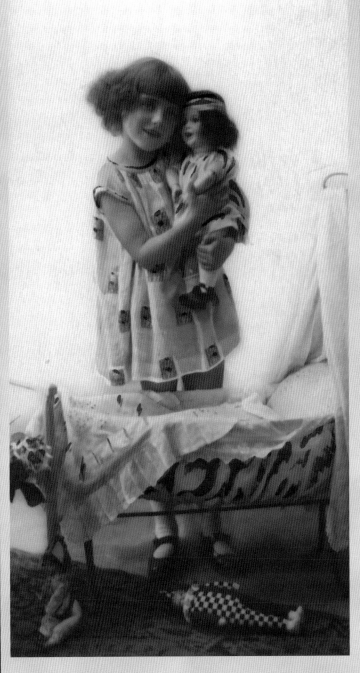

...I stopped for a moment in my lonely way under the starlight, and saw spread before me the darkened earth surrounding with her arms countless homes furnished with cradles and beds, mother's hearts and evening lamps, and young lives glad with a gladness that knows nothing of its value for the world.

Rabindranath Tagore
The Crescent Moon

Fig. 137
$3\frac{1}{2}$in x $5\frac{1}{2}$in (9cm x 14cm)
This circa 1920 French commercial real photo postcard features hand-tinted colors and a S.F.B.J. bisque head character baby with a realistic expression.

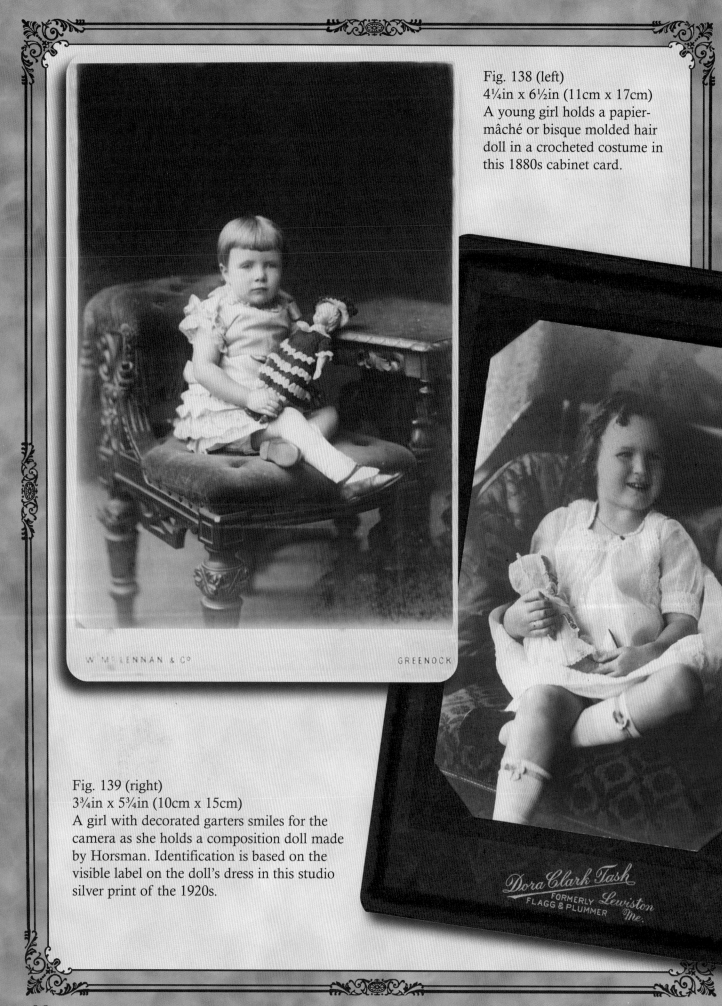

Fig. 138 (left)
4¼in x 6½in (11cm x 17cm)
A young girl holds a papier-mâché or bisque molded hair doll in a crocheted costume in this 1880s cabinet card.

W. McLENNAN & Cº GREENOCK

Fig. 139 (right)
3¾in x 5¾in (10cm x 15cm)
A girl with decorated garters smiles for the camera as she holds a composition doll made by Horsman. Identification is based on the visible label on the doll's dress in this studio silver print of the 1920s.

Dora Clark Tash
FORMERLY Lewiston
FLAGG & PLUMMER Me.

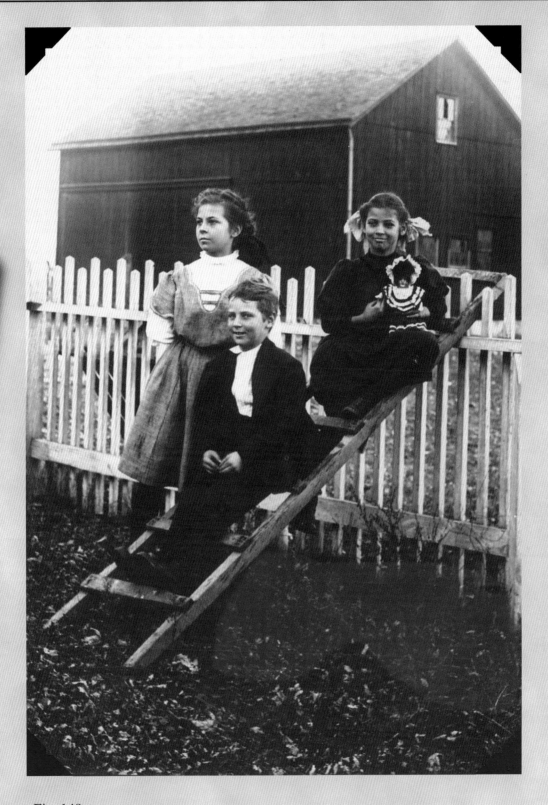

Fig. 140
3½in x 5½in (9cm x 14cm)
This real photo postcard, with a circa 1915 stamp box, depicts three children in a unique pose with a ladder. One girl holds a German bisque doll in a fancy costume.

North Side Art Gallery
GENESEO, ILLINOIS.

Fig. 141 (left)
4¼in x 6½in (11cm x 17cm)
This albumen cabinet card of the 1890s portrays two girls with a well-modeled German bisque head dolly-face doll. Their identical dresses have inset smocked panels at the neckline.

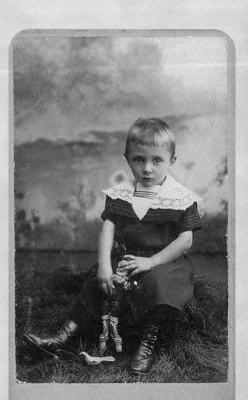

Eline Andersen Helsingør.

Fig. 142 (right)
2½in x 4in (6cm x 10cm)
This dated 1897 albumen carte de visite portrays a young boy holding an unusual German clown, probably made of papier-mâché, with tall platform boots. A carved wooden bird lies at his feet. *Jim and Janet Doud Collection.*

90

Fig. 143 (right)
$3\frac{3}{4}$in x $5\frac{1}{2}$in (10cm x 14cm)
A baby in a white eyelet dress
holds a much-loved doll printed
on cloth in this early 20th
century studio silver print.

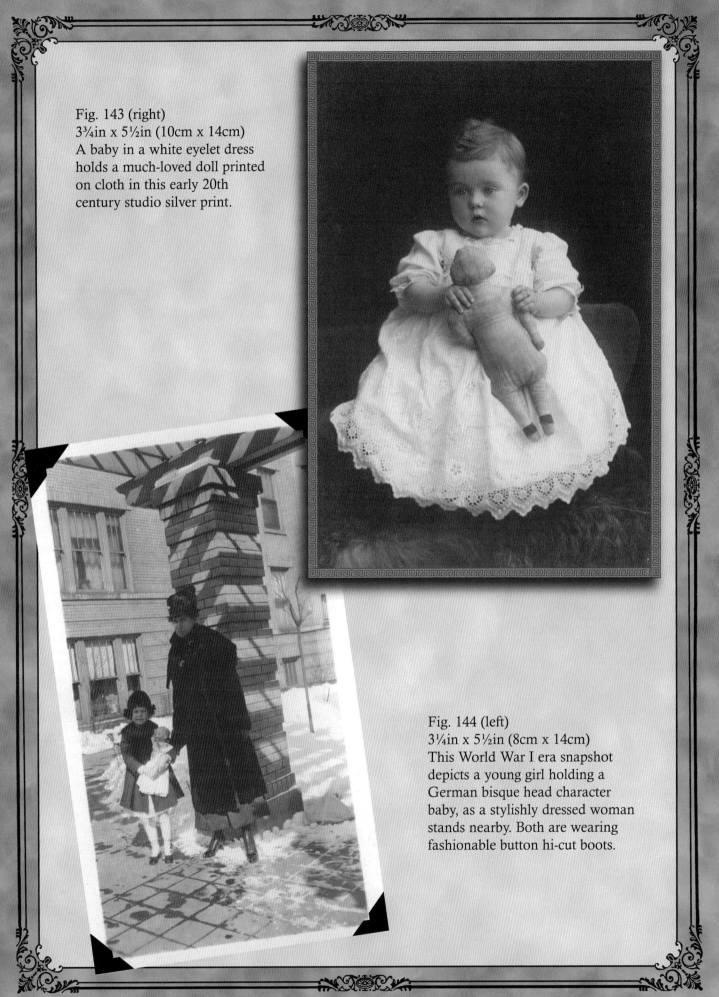

Fig. 144 (left)
$3\frac{1}{4}$in x $5\frac{1}{2}$in (8cm x 14cm)
This World War I era snapshot
depicts a young girl holding a
German bisque head character
baby, as a stylishly dressed woman
stands nearby. Both are wearing
fashionable button hi-cut boots.

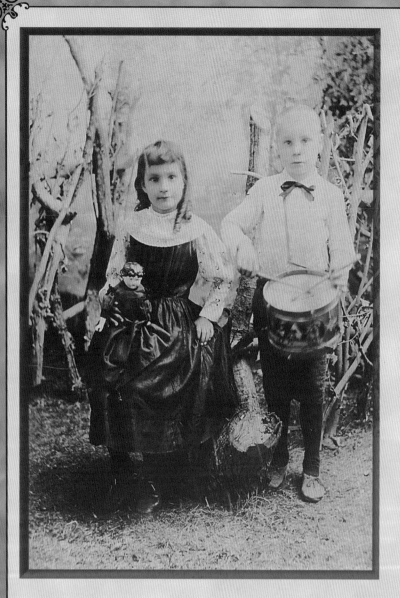

Fig. 145 (left)
$4\frac{1}{4}$in x $6\frac{1}{2}$in (11cm x 17cm)
A girl and boy pose against a rustic background in this albumen cabinet card. The girl holds a china doll of the 1880s that resembles models made by the German firm of Alt, Beck, and Gottshalck. The boy holds a wood drum with a lithographed image. *Jim and Janet Doud Collection.*

Fig. 146 (right)
$3\frac{1}{4}$in x $3\frac{1}{4}$in (8cm x 8cm)
Lori Ann smiles for the camera in this snapshot as she stands next to her vinyl doll she has named "Sissy." This doll resembles models made for the "Patti Playpal" family by Ideal in the late 1950s. *Lori McMurray Farmer Collection.*

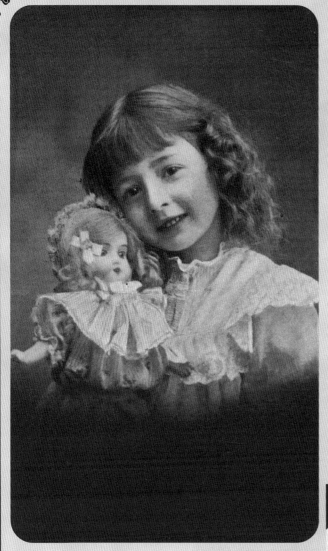

Fig. 147 (left)
3½in x 5½in (9cm x 14cm)
This commercial color photomechanical halftone postcard is an endearing image of a girl holding her German bisque head dolly-face doll, circa 1910. This doll has facial similarities to models produced by Armand Marseille.

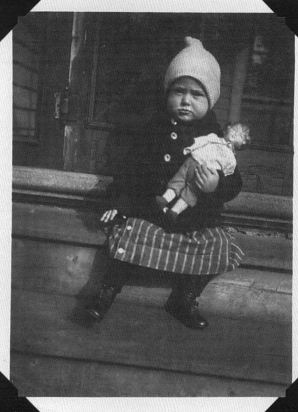

Fig. 148 (right)
3½in x 5½in (9cm x 14cm)
This character molded hair doll, that appears to be made of composition, resembles models made by the American firms of Louis Amberg & Son and Effanbee. This real photo postcard is circa World War I.

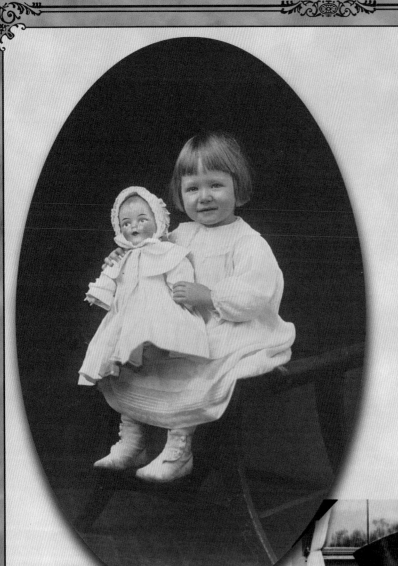

Fig. 149 (left)
3¼in x 5in (8cm x 13cm)
This trimmed real photo postcard, with a circa 1915 stamp box, shows an image of a toddler with a fashionably dressed baby doll. Composition wide-eyed babies of this type were produced by various American doll firms. *Jim and Janet Doud Collection.*

Fig. 150 (right)
3½in x 5¼in (9cm x 13cm)
Two children posed as adults in this dated 1908 real photo postcard admire a German bisque head doll. Simon & Halbig produced dolly-face models that resemble this example.

On the Birth of a Child

Lo, to the battle-ground of
 Life,
Child, you have come, like a
 conquering shout,
Out of the struggle—into strife;
Out of darkness—into doubt.

Girt with the fragile armor of
 youth,
Child, you must ride into endless
 wars,
With the sword of protest, the
 buckler of truth,
And a banner of love to sweep
 the stars.

About you the world's despair
 will surge;
Into defeat you must plunge
 and grope.
Be to the faltering an urge;
Be to the hopeless years a hope!

Be to the darkened world a
 flame;
Be to its unconcern a blow—
For out of its pain and tumult you
 came,
And into its tumult and pain you
 go.

 Louis Untermeyer
 Modern American Poetry

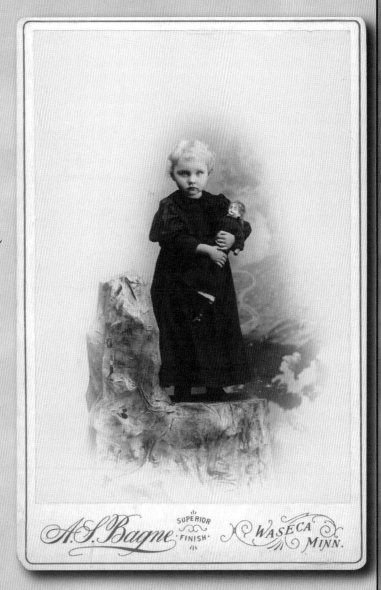

Fig. 151
4¼in x 6½in (11cm x 17cm)
This hauntingly beautiful albumen cabinet card portrait
of the 1890s depicts a child with a German dolly-face
doll with a bisque head.

95

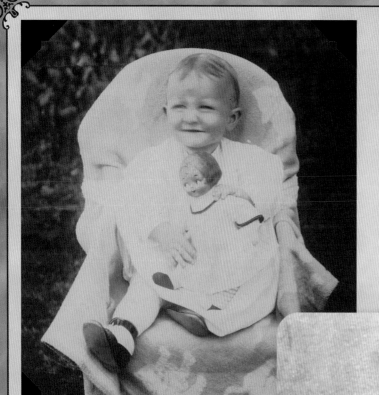

Fig. 152 (left)
3½in x 5½in (9cm x 14cm)
In this real photo postcard, a toddler holds a doll that strongly resembles a 1910 Horsman composition "Campbell Kid" inspired by Grace Drayton's characters.

Fig. 153 (right)
3½in x 5½in (9cm x 14cm)
This European real photo postcard of the early 1900s is an unusual study of a young boy dressed in an elf or jester-type costume. He holds a marotte, a toy with a doll's head on a stick. When twirled, the marotte usually produced music.
Jim and Janet Doud Collection.

J. J. Foster, TRAVELING PHOTOGRAPHER.

Fig. 154
4¼in x 6½in (11cm x 17cm)
A girl stares intently into the camera in this albumen cabinet card of the
1890s. Her superior quality German bisque head doll resembles beautiful
models made by J.D. Kestner.

Fig. 155
3½in x 5¼in (9cm x 13cm)
This humorous real photo postcard, dated 1921, portrays the scene of a child giving a haircut to a doll. Both cloth dolls resemble uniformed examples produced by the Steiff factory in Germany.

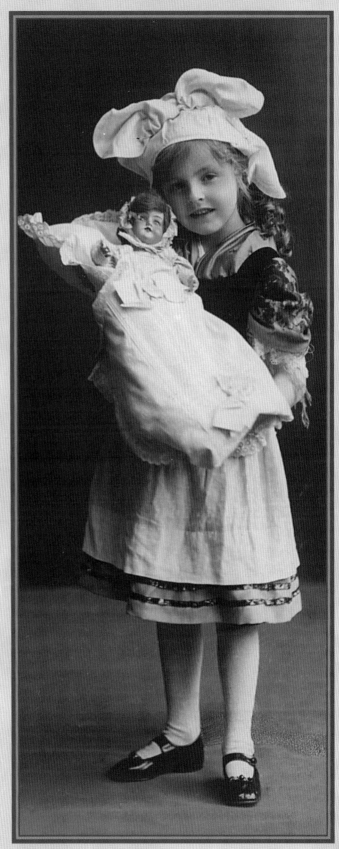

Fig. 156 (above)
4in x 6in (10cm x 15cm)
A little girl in a child-size caned rocker
holds a large German doll, possibly a
patent washable papier-mâché or a bisque
head model. This photograph was printed
from an old glass plate, circa 1890. *Jim and
Janet Doud Collection.*

Fig. 157 (right)
3¼in x 5¼in (8cm x 13cm)
In this circa 1915 real photo postcard, a
girl in a regional costume holds a wigged
bisque head character baby, probably
made by a German firm.

Fig. 158
6in x 9in (15cm x 23cm)
This endearing studio silver print of the pre-World War I era portrays a girl
with a character baby doll made with a bisque or composition head.

Fig. 159 (right)
4¼in x 6½in (11cm x 17cm)
A girl in a plaid dress of the 1890s
holds a German bisque head
dolly-face doll. She poses with a
boy holding flowers in this albumen
cabinet card. *Jim and Janet Doud
Collection.*

Fig. 160 (below)
2½in x 4in (6cm x 10cm)
This whimsical circa 1860 albumen
carte de visite shows a boy with his
tiny unjointed china "Frozen
Charlotte" doll. *Jim and Janet Doud
Collection.*

The Little Elf

I met a little elf-man, once,
Down where the lilies blow.
I asked him why he was so small,
And why he didn't grow.

He slightly frowned, and with his eye
He looked me through and through.
"I'm quite as big for me," said he,
"As you are big for you."

John Kendrick Bangs

101

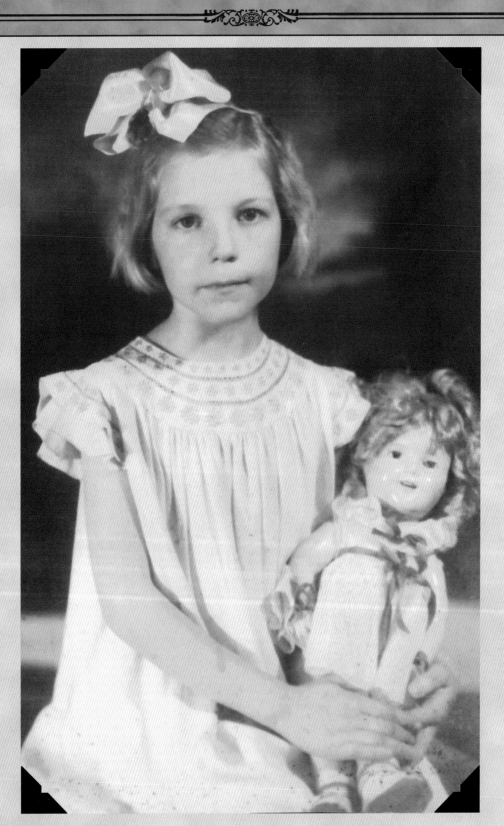

Fig. 161
4¼in x 6½in (11cm x 17cm)
A serious girl poses with a composition doll strongly resembling "Shirley Temple", produced by the Ideal Novelty & Toy Company during the 1930s. The doll appears to be wearing her original factory outfit in this silver print even though her mohair wig is disheveled. *Jim and Janet Doud Collection.*

Fig. 162 (right)
3½in x 5½in (9cm x 14cm)
This commercial color
photomechanical halftone in a
circa 1910 postcard format
depicts a child and her dolls in
a stenciled bed.

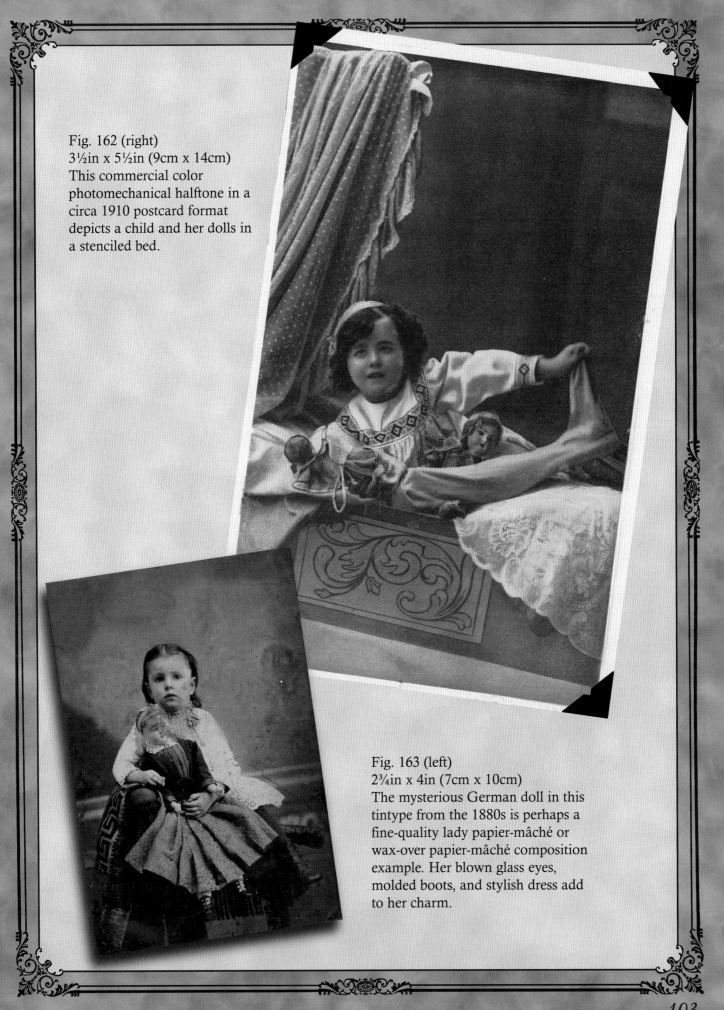

Fig. 163 (left)
2¾in x 4in (7cm x 10cm)
The mysterious German doll in this
tintype from the 1880s is perhaps a
fine-quality lady papier-mâché or
wax-over papier-mâché composition
example. Her blown glass eyes,
molded boots, and stylish dress add
to her charm.

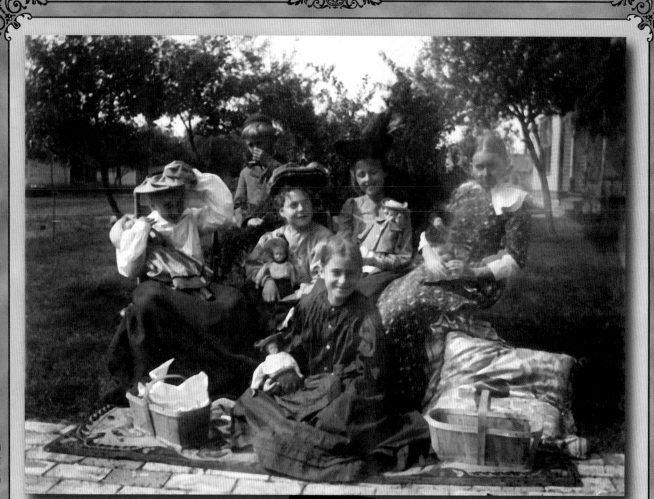

Fig. 164 (above)
6½in x 5½in (17cm x 14cm)
The elaborate picnic scene in this
circa 1890s albumen print makes it
quite desirable. It comes complete
with oriental carpet, cushions,
baskets, one boy, and five girls in
dress-up clothes holding their dolls.

Fig. 165 (right)
3in x 3¼in (8cm x 8cm)
This unique circa 1900 albumen
print of a family in their bedroom
is very special. The image of the
photographer with his camera is
accidentally reflected in the
dresser mirror.

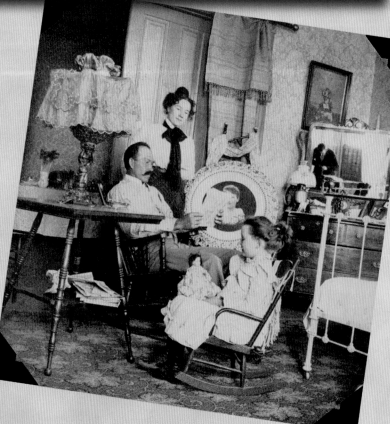

Fig. 166 (below)
3½in x 3½in (9cm x 9cm)
This 1950s Kodacolor snapshot portrays Mary Diane
with her bonnet doll birthday cake.

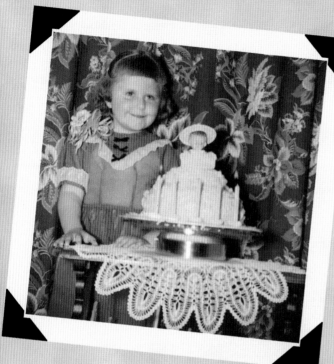

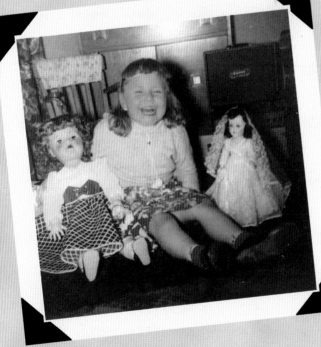

Fig. 167 (above)
3½in x 3½in (9cm x 9cm)
Mary Diane smiles in this 1950s Kodacolor print
with her vinyl and latex Ideal doll she named
"Priscilla" and her Arranbee hard plastic bride doll.

First Arrivals

It is a Party, do you know,
And there they sit, all in a
 row,
Waiting till the others come,
To begin to have some fun.

Hark! the bell rings sharp
 and clear,
Other little friends appear;
And no longer all alone
They begin to feel at home.

To them a little hard is Fate,
Yet better early than too late;
Fancy getting there forlorn,
With the tea and cake all
 gone.

Wonder what they'll have for
 tea;
Hope the jam is strawberry.
Wonder what the dance and
 game;
Feel so very glad they came.

Very Happy may you be,
May you much enjoy your
 tea.

Kate Greenaway
Marigold Garden

105

Fig. 168 (above)
4¼in x 6½in (11cm x 17cm)
This circa 1880 albumen cabinet card depicts a girl standing near a china doll with blond molded hair. The girl's beautiful lace-trimmed petticoat and detachable collar were common in styles of this period.

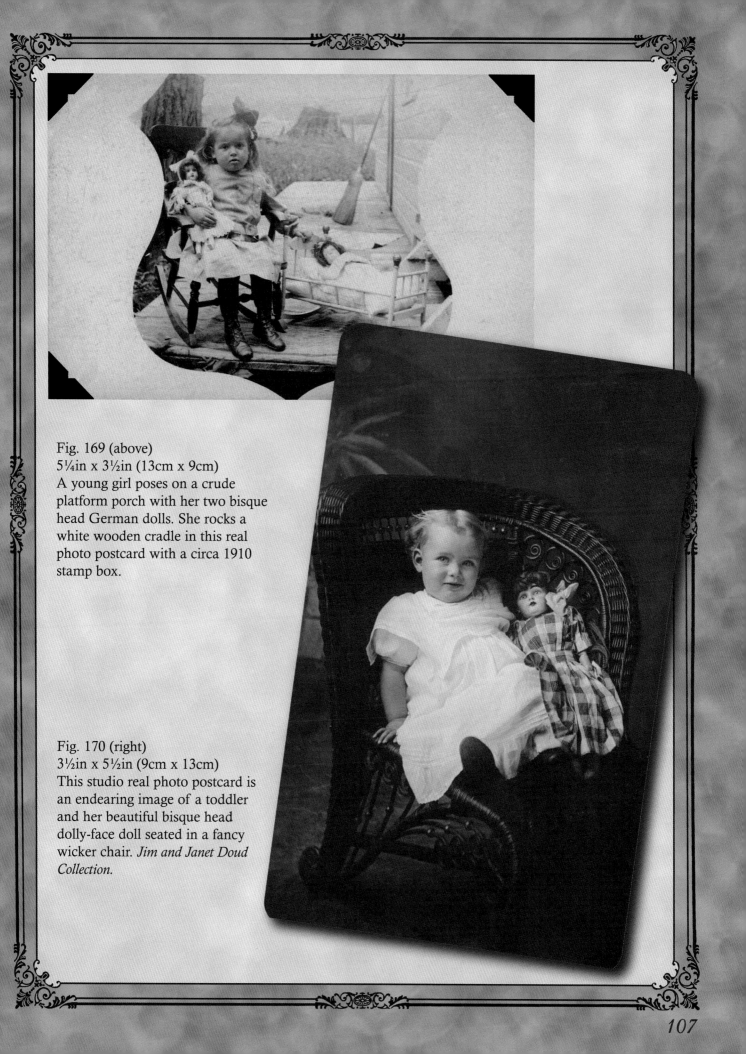

Fig. 169 (above)
5¼in x 3½in (13cm x 9cm)
A young girl poses on a crude platform porch with her two bisque head German dolls. She rocks a white wooden cradle in this real photo postcard with a circa 1910 stamp box.

Fig. 170 (right)
3½in x 5½in (9cm x 13cm)
This studio real photo postcard is an endearing image of a toddler and her beautiful bisque head dolly-face doll seated in a fancy wicker chair. *Jim and Janet Doud Collection.*

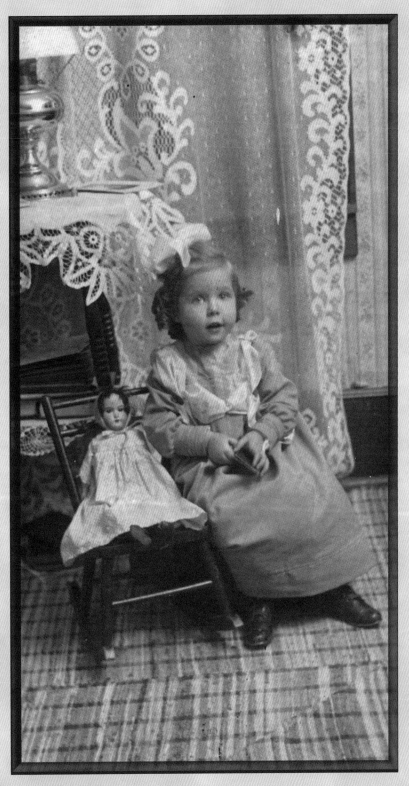

Fig. 171 (left)
3½in x 6in (9cm x 15cm)
Three different laces are represented in the background of this circa 1900 silver print. A girl sits beside her German bisque head dolly-face doll that resembles models made by the doll firms of Armand Marseille or Heubach Köppelsdorf.

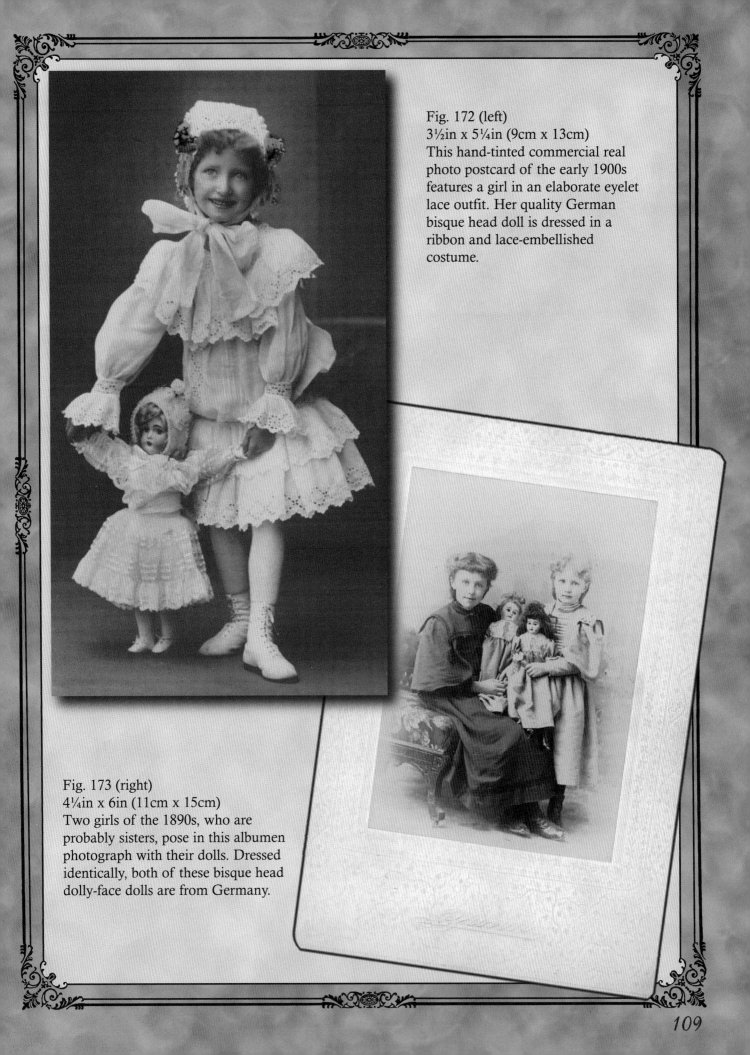

Fig. 172 (left)
3½in x 5¼in (9cm x 13cm)
This hand-tinted commercial real photo postcard of the early 1900s features a girl in an elaborate eyelet lace outfit. Her quality German bisque head doll is dressed in a ribbon and lace-embellished costume.

Fig. 173 (right)
4¼in x 6in (11cm x 15cm)
Two girls of the 1890s, who are probably sisters, pose in this albumen photograph with their dolls. Dressed identically, both of these bisque head dolly-face dolls are from Germany.

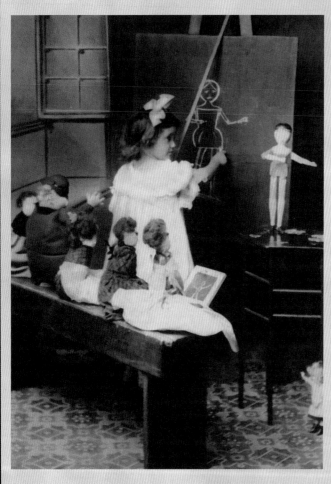

Fig. 174
3½in x 5½in (9cm x 14cm)
This commercial real photo postcard of the
early 20th century is an amusing scene of a
young girl teaching her dolls how to draw. Her
model appears to be a German peg wooden doll
of the period.

My Life's Dream

I hear my teacher's voice so
 clear,
"Art is life, and life's so dear."

To feel, to see, to hear my heart,
To paint, to draw, for me is art.

It's made each day so bright, so
 fair,
Such wondrous joy, a gift so rare.

So thanks for teacher's words to
 me,
By showing how through art I
 see.

Through visions of my magic
 scheme,
My art, my art, is my life dream.
My art, my art, is my life dream.

 M.M. Wikert

110

RASMUSSEN Rock Island. Ill

Fig. 175 (left)
4¼in x 6½in (11cm x 17cm)
A serene girl stands by the side of her German bisque head doll in this albumen cabinet card of the 1890s. This doll has a mohair wig full of curls, a white coat with a shoulder cape, and a velvet hat.

Fig. 176 (right)
3½in x 5½in (9cm x 14cm)
This real photo postcard, with a circa 1915 stamp box, portrays two plainly dressed girls with their elaborately costumed bisque head dolls. These German dolly-face dolls resemble examples produced by J. D. Kestner.

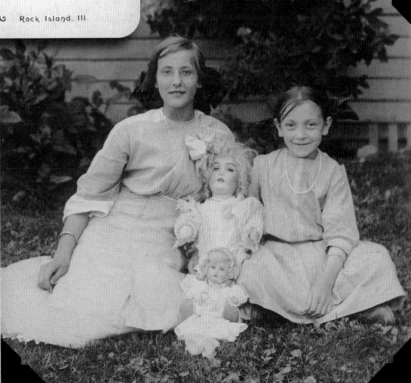

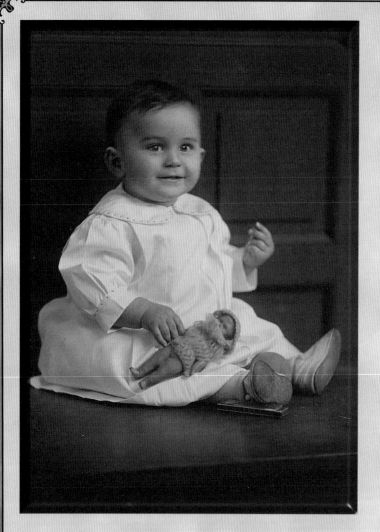

Fig. 177 (left)
4in x 6in (10cm x 15cm)
A baby poses for this early 20th century studio silver print portrait as he holds a German bisque unjointed "Frozen Charlotte" with crocheted clothes. A harmonica lies by his foot. *Jim and Janet Doud Collection.*

Fig. 178 (below)
3¼in x 3¾in (8cm x 10cm)
This tintype of the early 1880s is an extraordinary image of two stylishly dressed girls with their German lady dolls, possibly made of papier-mâché or wax-over papier-mâché composition. The case, although from the 1860s, compliments and protects the tintype.

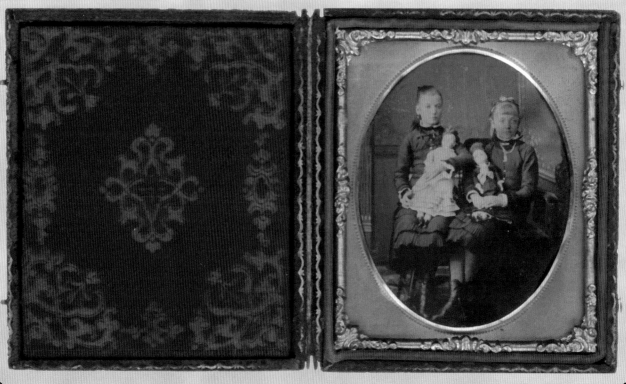

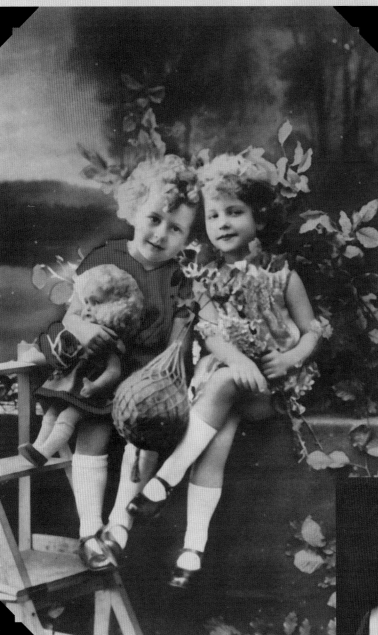

Fig. 179 (left)
3½in x 5¼in (9cm x 13cm)
Two children pose for the camera in this French commercial hand-tinted real photo post card of the 1920s. The girl in red holds what appears to be a felt child doll. Various French, Italian, and English firms made dolls of this type.

Fig. 180 (right)
3½in x 5½in (9cm x 14cm)
This unusual real photo postcard, with a circa 1910 stamp box, portrays a child with her nurse. She cradles a German bisque head doll in her arm as she proudly poses for the camera.

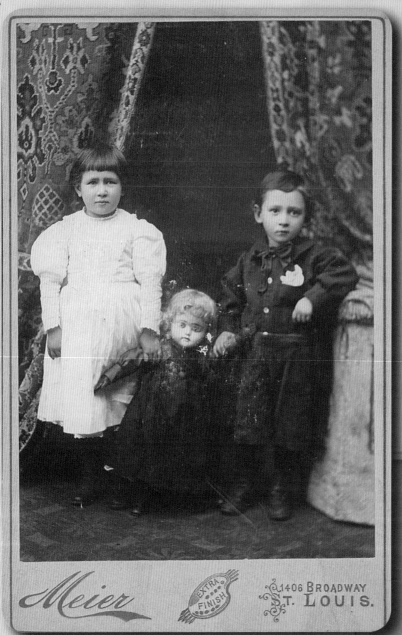

Meier EXTRA FINISH 1406 BROADWAY ST. LOUIS.

Fig. 181 (left)
4¼x 6½(11 cm x 17cm)
This probable German patent washable papier-mâché doll in this cabinet card of the 1890s has extraordinary blown glass eyes and leather hands. The girl's dress has leg-o'-mutton sleeves, characteristic of this period. *Jim and Janet Doud Collection.*

Fig. 182 (right)
2½in x 4 in (6cm x 10cm)
This delicately tinted albumen carte de visite of the 1860s is a simple portrait of a young girl. What appears to be an early china head boy sits on a carved chair nearby. *Jim and Janet Doud Collection.*

Fig. 183 (right)
3¾in x 5¾in (10cm x 15cm)
A boy in overalls and straw hat poses in this studio silver print. Seated nearby is an American composition doll strongly resembling Horsman's "Campbell Kid". It was first produced in 1910.

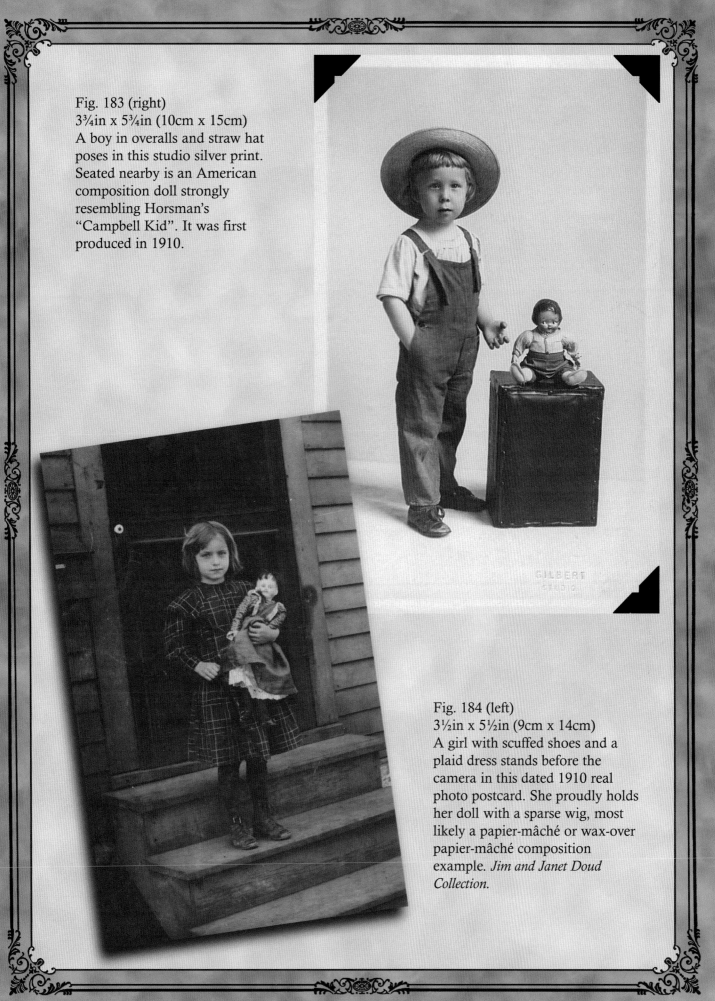

Fig. 184 (left)
3½in x 5½in (9cm x 14cm)
A girl with scuffed shoes and a plaid dress stands before the camera in this dated 1910 real photo postcard. She proudly holds her doll with a sparse wig, most likely a papier-mâché or wax-over papier-mâché composition example. *Jim and Janet Doud Collection.*

115

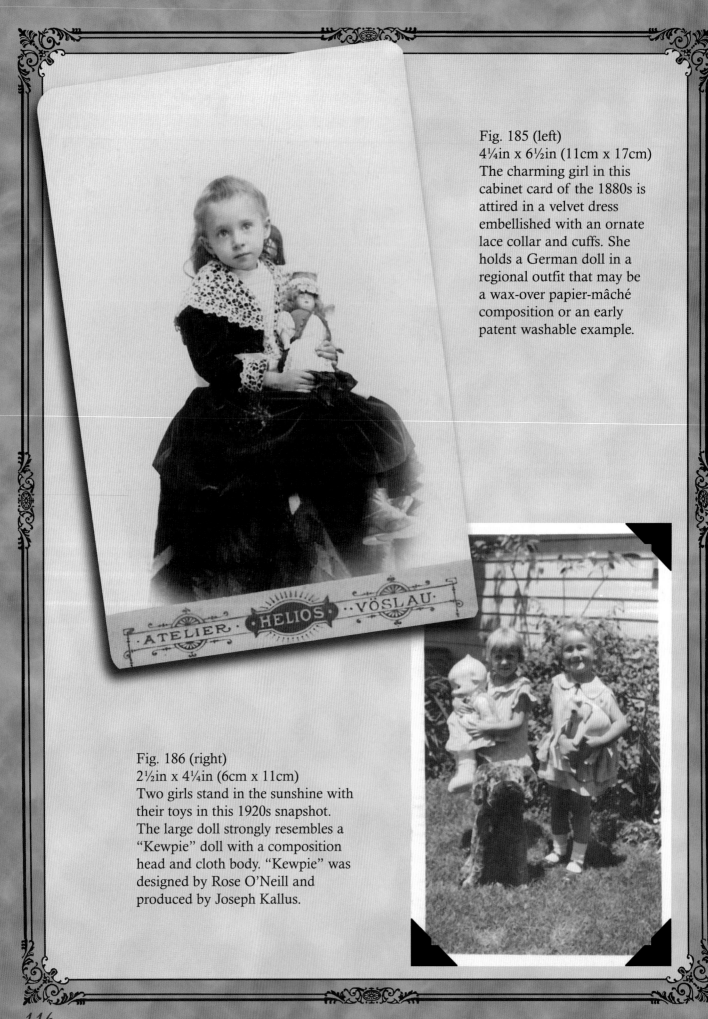

Fig. 185 (left)
4¼in x 6½in (11cm x 17cm)
The charming girl in this cabinet card of the 1880s is attired in a velvet dress embellished with an ornate lace collar and cuffs. She holds a German doll in a regional outfit that may be a wax-over papier-mâché composition or an early patent washable example.

· ATELIER · HELIOS · VÖSLAU ·

Fig. 186 (right)
2½in x 4¼in (6cm x 11cm)
Two girls stand in the sunshine with their toys in this 1920s snapshot. The large doll strongly resembles a "Kewpie" doll with a composition head and cloth body. "Kewpie" was designed by Rose O'Neill and produced by Joseph Kallus.

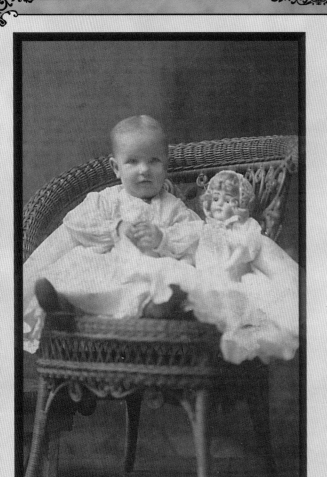

Fig. 187 (left)
3½in x 5in (9cm x 13cm)
This circa 1910 silver print portrays a baby seated in an ornate wicker chair with a German bisque head dolly-face doll close at hand. *Jim and Janet Doud Collection.*

Fig. 188 (right)
2¾in x 3¾in (7cm x 10cm)
A toddler dressed in hat, coat and gloves sits for the photographer in this circa 1905 silver print. She cradles a cloth printed doll, which has similarities to "Buster Brown," best known as the cartoon character trademark for the Brown Shoe Company.

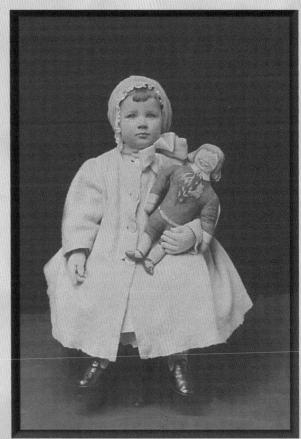

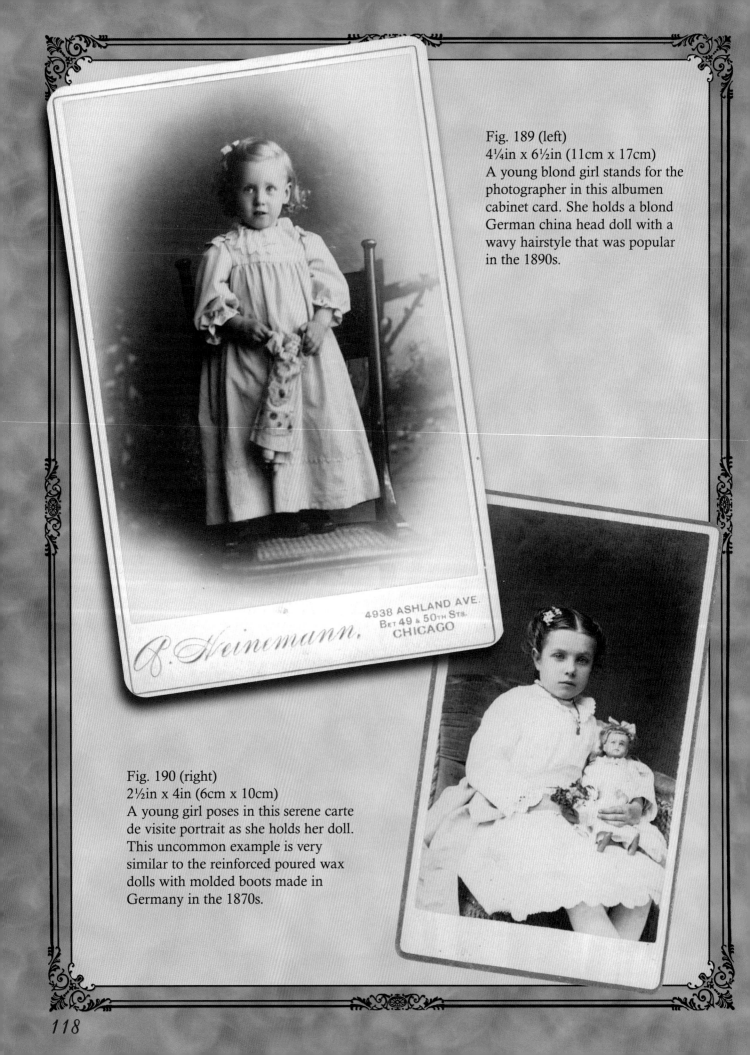

Fig. 189 (left)
$4\frac{1}{4}$in x $6\frac{1}{2}$in (11cm x 17cm)
A young blond girl stands for the photographer in this albumen cabinet card. She holds a blond German china head doll with a wavy hairstyle that was popular in the 1890s.

P. Heinemann.
4938 ASHLAND AVE.
BET 49 & 50TH STS.
CHICAGO

Fig. 190 (right)
$2\frac{1}{2}$in x 4in (6cm x 10cm)
A young girl poses in this serene carte de visite portrait as she holds her doll. This uncommon example is very similar to the reinforced poured wax dolls with molded boots made in Germany in the 1870s.

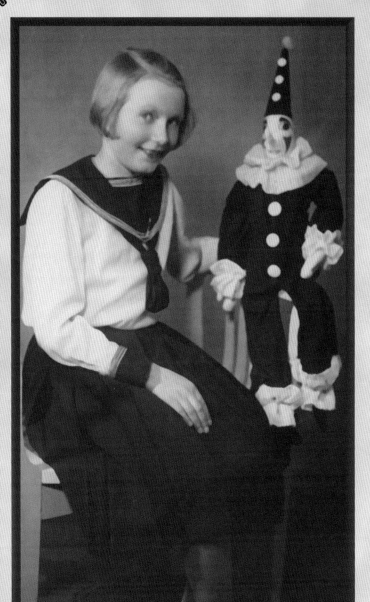

XXXVIII

*A **Little** madness in the Spring
Is wholesome even for the King,
But God be with the Clown,
Who ponders this tremendous scene—
This whole experiment of green,
As if it were his own!*

Emily Dickinson
The Single Hound
Complete Poems

Fig. 191
3¼in x 5¼in (8cm x 13cm)
This European real photo postcard of the 1920s is a
unique study in black and white. A girl in a sailor midi
outfit sits beside a handsome cloth clown doll whose
costume is similar to one worn by Pierrot, a character
from the *Commedia Dell'arte*.

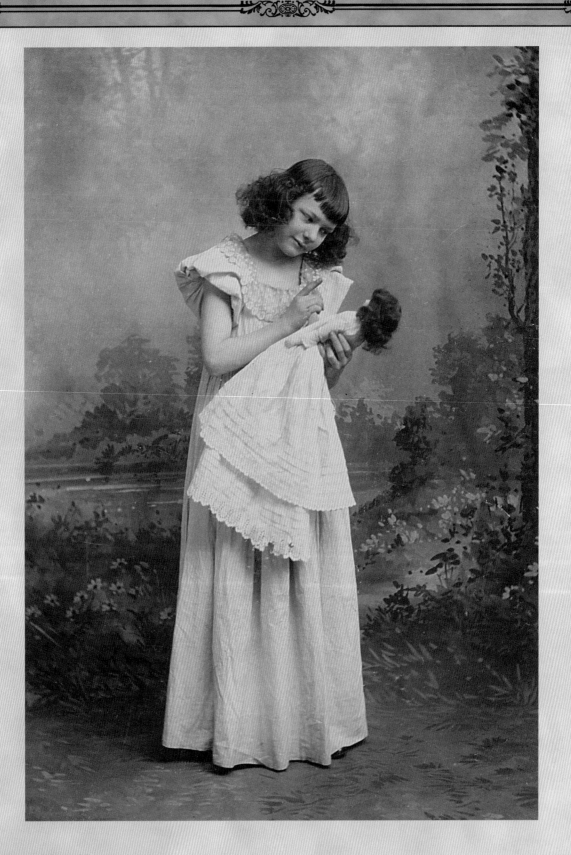

Fig. 192
4in x 5½in (10cm x 14cm)
This circa 1890 albumen photograph depicts an old-fashioned scene of a girl scolding her doll. The doll wears a dress and slip with tucking and eyelet lace.

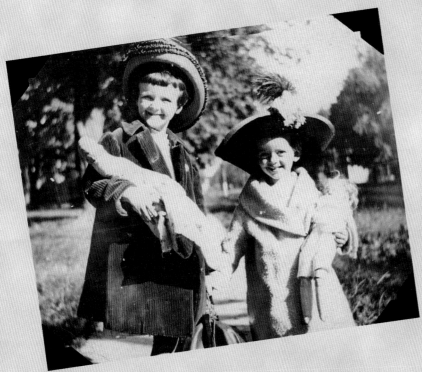

Fig. 193 (left)
4¼in x 3¼in (11cm x 8cm)
The photographer of this delightful silver print of the early 1900s has captured the image of two girls in dress-up clothes. Their smiles express their delight in displaying their dolls. A cloth doll is on the left and a German bisque head doll with a kid body is on the right. *Jim and Janet Doud Collection.*

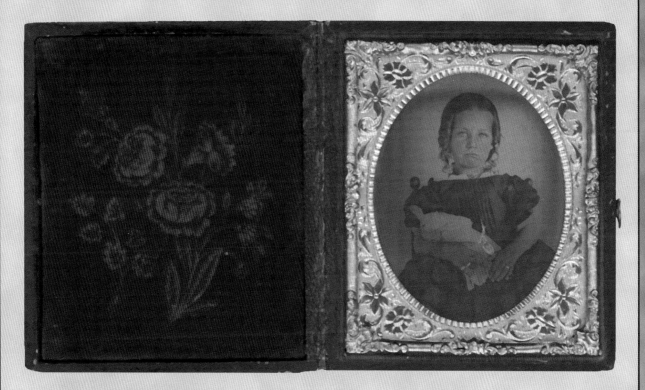

Fig. 194 (above)
3¼in x 3½in (8cm x 9cm)
This uncommon cased ambrotype with an ornate decorative mat, circa 1860, is a portrait of a young girl holding a china head doll with an 1840s hairstyle. The girl's rings and necklace have been highlighted in gold.

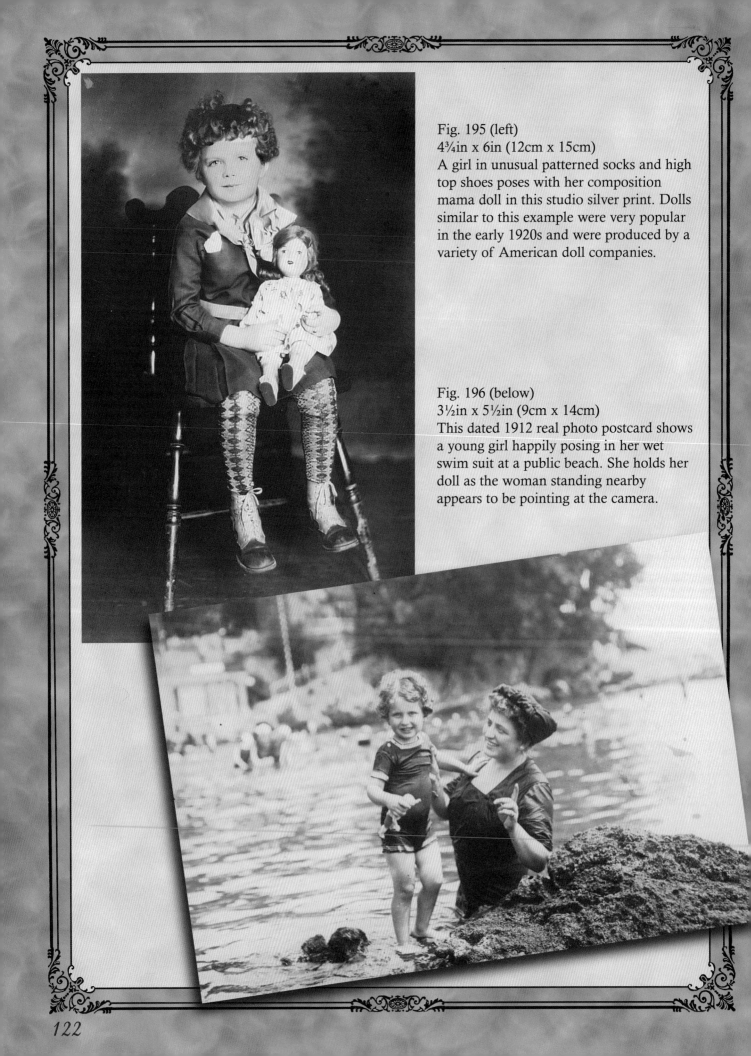

Fig. 195 (left)
4¾in x 6in (12cm x 15cm)
A girl in unusual patterned socks and high top shoes poses with her composition mama doll in this studio silver print. Dolls similar to this example were very popular in the early 1920s and were produced by a variety of American doll companies.

Fig. 196 (below)
3½in x 5½in (9cm x 14cm)
This dated 1912 real photo postcard shows a young girl happily posing in her wet swim suit at a public beach. She holds her doll as the woman standing nearby appears to be pointing at the camera.

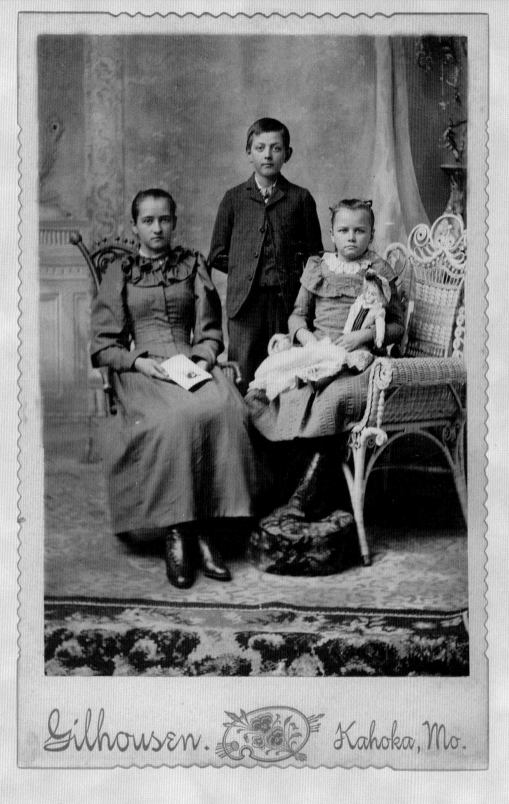

Gilhousen. Kahoka, Mo.

Fig. 197
4¼in x 6½in (11cm x 17cm)
Three children seriously pose for the camera in this albumen cabinet card of
the 1880s. The youngest girl holds a nicely costumed German bisque head
doll with a dolly-face. *Jim and Janet Doud Collection.*

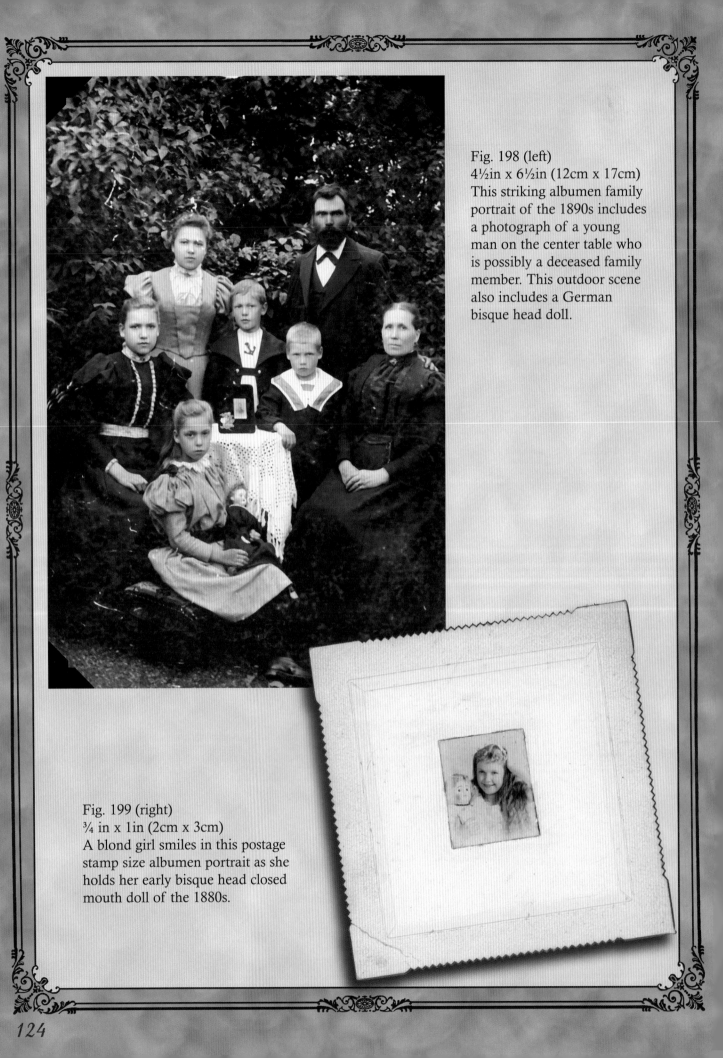

Fig. 198 (left)
4½in x 6½in (12cm x 17cm)
This striking albumen family portrait of the 1890s includes a photograph of a young man on the center table who is possibly a deceased family member. This outdoor scene also includes a German bisque head doll.

Fig. 199 (right)
¾ in x 1in (2cm x 3cm)
A blond girl smiles in this postage stamp size albumen portrait as she holds her early bisque head closed mouth doll of the 1880s.

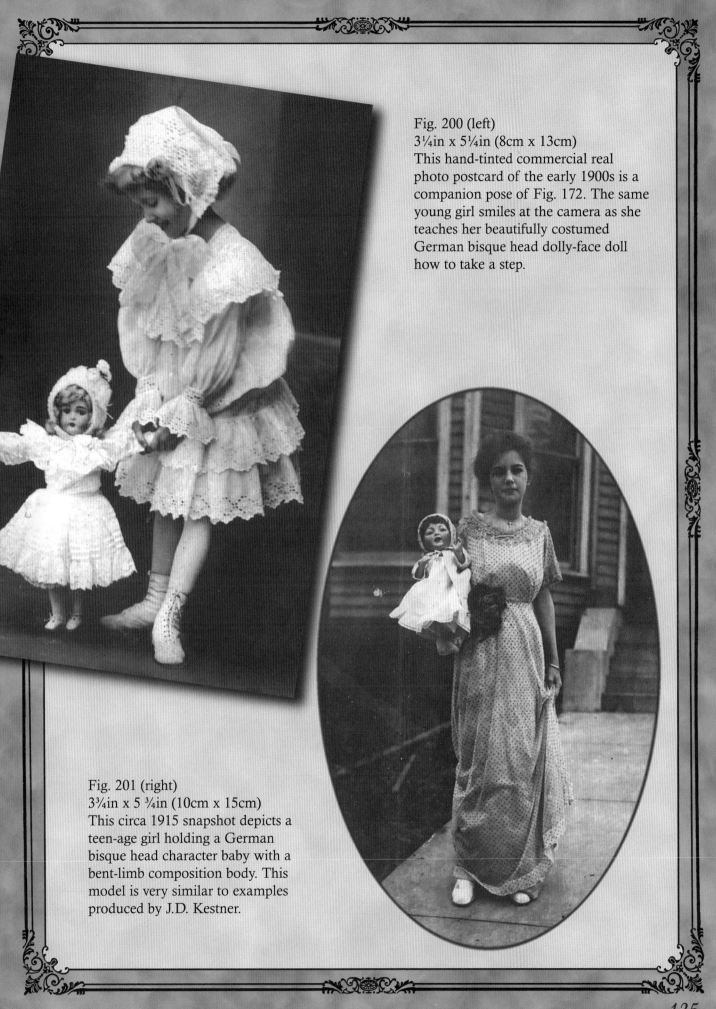

Fig. 200 (left)
3¼in x 5¼in (8cm x 13cm)
This hand-tinted commercial real photo postcard of the early 1900s is a companion pose of Fig. 172. The same young girl smiles at the camera as she teaches her beautifully costumed German bisque head dolly-face doll how to take a step.

Fig. 201 (right)
3¾in x 5 ¾in (10cm x 15cm)
This circa 1915 snapshot depicts a teen-age girl holding a German bisque head character baby with a bent-limb composition body. This model is very similar to examples produced by J.D. Kestner.

Fig. 202 (right)
4¼in x 6½in (11cm x 17cm)
A girl stands in a relaxed pose with her well-costumed German bisque head doll. The girl's dress features leg-o'-mutton sleeves, a full skirt, and a gathered bodice panel in this 1890s albumen cabinet card.

Fig. 203 (below)
5½in x 3½in (14cm x 9cm)
This interior real photo postcard scene, postmarked 1915, shows a young girl with two of her German bisque head dolls. Both are stylishly dressed in coats and hats, ready for a ride in their folding doll gocart.

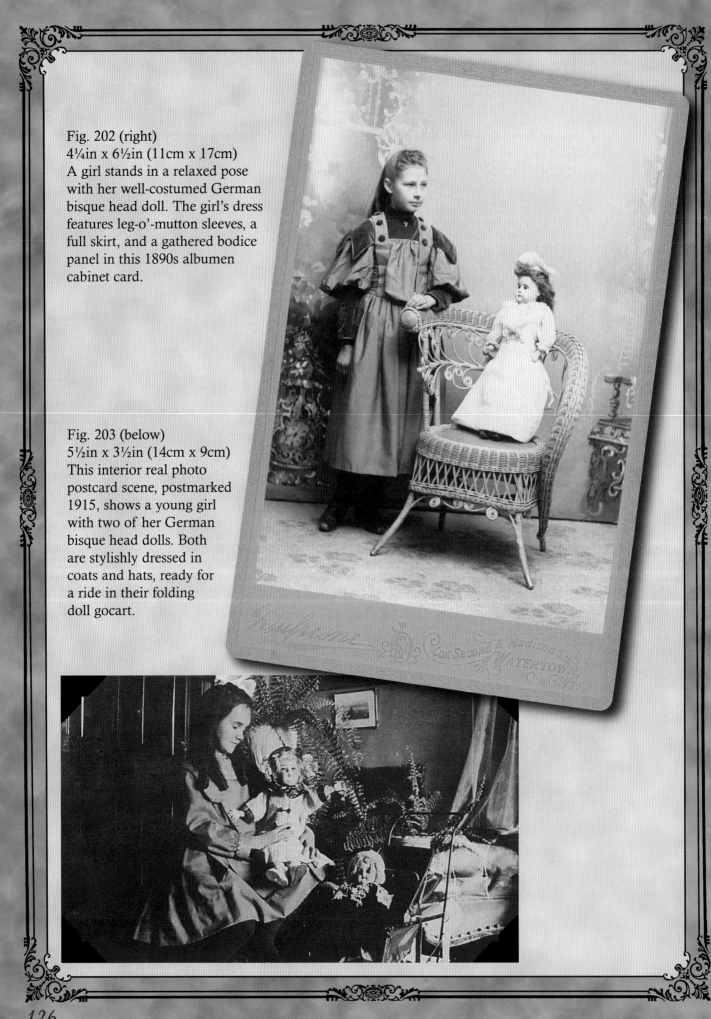

Fig. 204
3½in x 5½in
(9cm x 14cm)
A young girl lovingly holds a German bisque head dolly-face doll in this commercial European real photo postcard, circa 1910.

"Where have I come from, where did you pick me up?" the baby asked its mother.

She answered half crying, half laughing, and clasping the baby to her breast,—"You were hidden in my heart as its desire, my darling.

You were in the dolls of my childhood's game; and when with clay I made the image of my god every morning, I made and unmade you then.

You were enshrined with our household deity, in his worship I worshipped you.

In all my hopes and my loves, in my life, in the life of my mother you have lived..."

From
"The Beginning"
Rabindranath Tagore
The Crescent Moon

127

Fig. 205
4in x 5½in (10cm x 14cm)
A toddler balances on the arm of a Victorian wicker settee with two bisque head dolls in this circa 1905 studio silver print. Her doll family also includes a large cloth printed doll, probably produced by Art Fabric Mills, and two smaller cloth dolls that strongly resemble the grandsons of "Foxy Grandpa" inspired by Carl Shultze's comic strip characters.

Fig. 206 (right)
3½in x 5½in (9cm x 14cm)
This circa 1920 European real photo postcard shows a large cloth child doll with a mohair wig and painted features. Various French, Italian, and English doll firms made examples of this type of cloth doll.

Fig. 207 (left)
2½in x 4in (6cm x 10cm)
A delicately hand-colored tintype in a carte de visite "gem" format of the 1860s portrays a girl in simple dress. She holds a small blond doll with molded hair that resembles a bisque parian example. *Jim and Janet Doud Collection.*

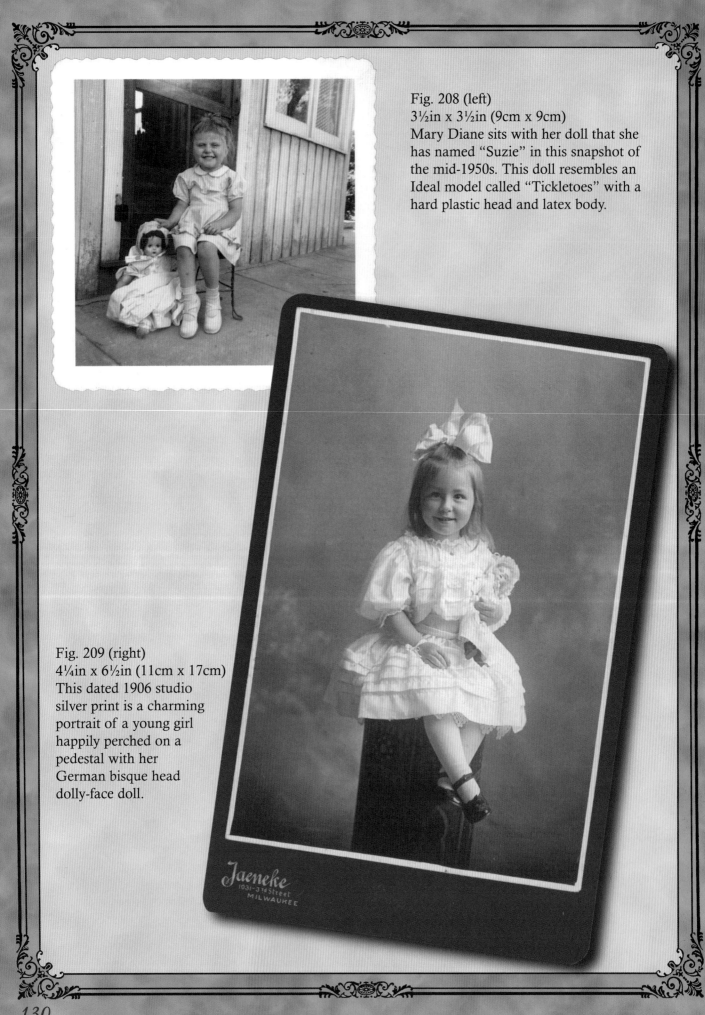

Fig. 208 (left)
3½in x 3½in (9cm x 9cm)
Mary Diane sits with her doll that she has named "Suzie" in this snapshot of the mid-1950s. This doll resembles an Ideal model called "Tickletoes" with a hard plastic head and latex body.

Fig. 209 (right)
4¼in x 6½in (11cm x 17cm)
This dated 1906 studio silver print is a charming portrait of a young girl happily perched on a pedestal with her German bisque head dolly-face doll.

130

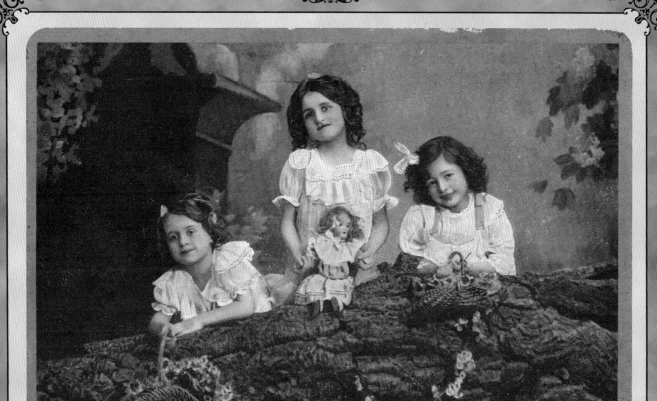

Fig. 210 (above)
5½in x 3½in (14cm x 9cm)
Three girls pose for the photographer
in this tinted photomechanical
halftone postcard with a 1909
postmark and gold border. The doll is
a German bisque head dolly-face doll.

Fig. 211 (right)
3¾in x 5in (10cm x 13cm)
This circa 1900 studio silver print
image portrays a girl tenderly holding
her faceless homemade cloth doll.
This photograph documents the loving
relationship between child and doll.
Jim and Janet Doud Collection.

Fig. 212 (right)
4in x 6in (10cm x 15cm)
The cloth doll in this commercial color photomechanical halftone postcard strongly resembles an example created by Käthe Kruse. This particular model, first produced in 1929 in Germany, has a human hair wig and painted features. *Jim and Janet Doud Collection.*

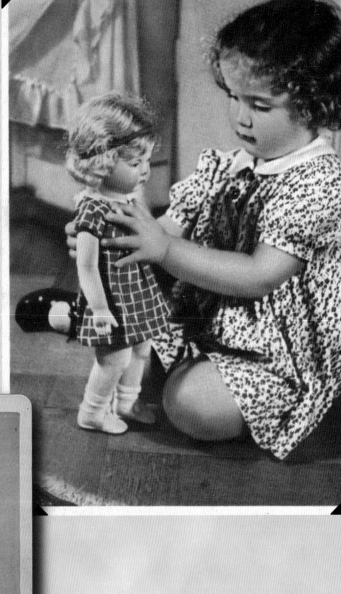

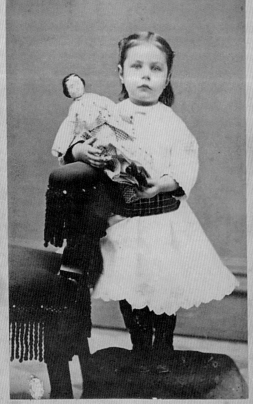

Fig. 213 (left)
2½in x 4in (6cm x 10cm)
The china head doll in this albumen carte de visite has a hairdo first produced in the 1860s. Her body is probably made of cloth with china lower limbs. *Jim and Janet Doud Collection.*

132

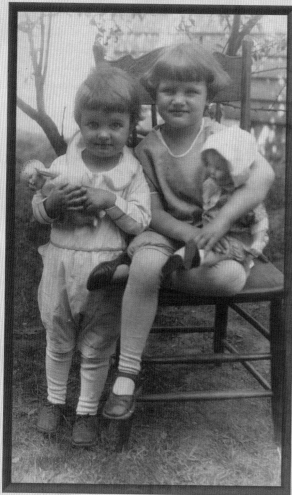

Fig. 214 (left)
3in x 4½in (8cm x 12cm)
Two young girls, who may be sisters, pose before the camera in this silver print of the 1920s. One is standing with a small composition baby doll, and the seated girl holds a composition mama doll.

Fig. 215 (right)
3½in x 5½in (9cm x 14cm)
This real photo postcard, with a 1907 stamp box, shows a boy and a girl standing outdoors. The girl holds a pretty German bisque head doll with a mohair or human hair wig. *Jim and Janet Doud Collection.*

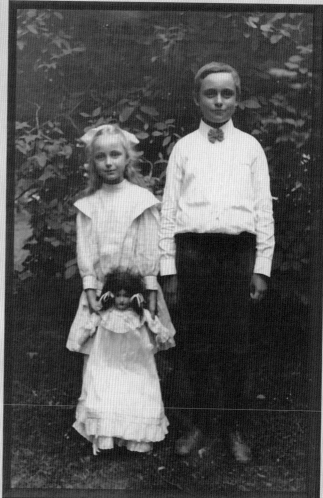

Fig. 216 (right)
4in x 5in (10cm x 13cm)
A girl sits with her German
bisque head character doll in a
large upholstered leather rocker
with carved wooden feet. The
object around her neck is
unidentified in this snapshot,
dated 1914. *Jim and Janet Doud
Collection.*

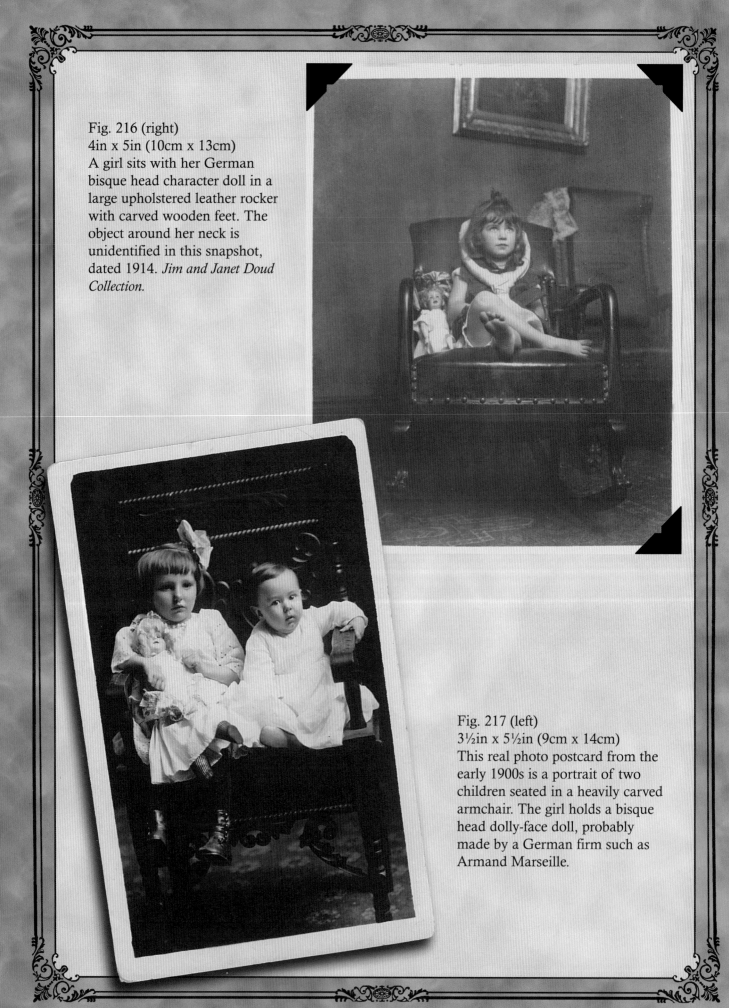

Fig. 217 (left)
3½in x 5½in (9cm x 14cm)
This real photo postcard from the
early 1900s is a portrait of two
children seated in a heavily carved
armchair. The girl holds a bisque
head dolly-face doll, probably
made by a German firm such as
Armand Marseille.

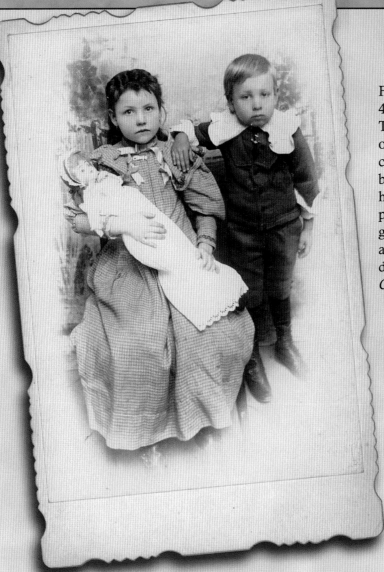

Fig. 218 (left)
4¼in x 6½in (11cm x 17cm)
This albumen cabinet card of the 1890s depicts two children seriously posing before the camera. The girl holds a patent washable papier-mâché doll with glass eyes and costumed in a bonnet and a long white dress. *Jim and Janet Doud Collection.*

Love Between Brothers and Sisters

Whatever brawls disturb the street,
There should be peace at home.
Where sisters dwell and brothers meet,
Quarrels should never come.

Birds in their little nests agree;
And 'tis a shameful sight,
When children of one family
Fall out and chide and fight.

Isacc Watts

135

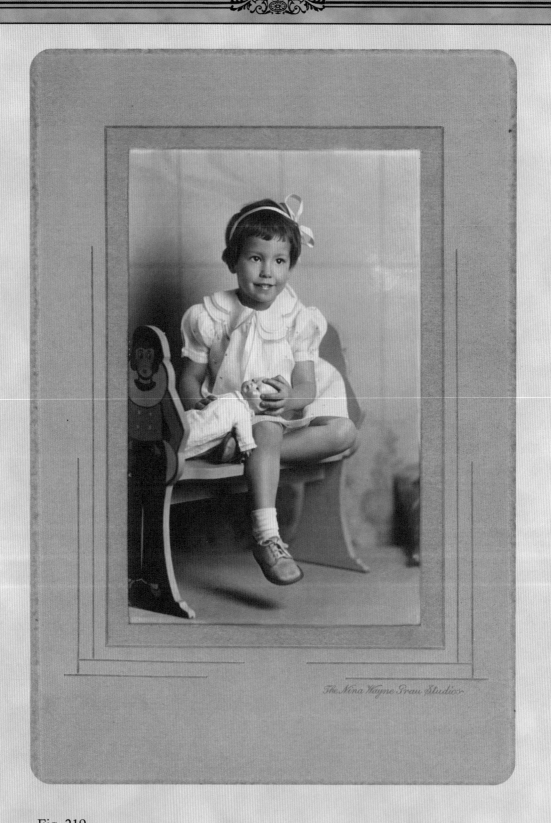

The Nina Wayne Prau Studio

Fig. 219
6in x 9in (15cm x 23cm)
A girl carefully holds her American composition baby doll on a figured bench in this 1920s studio silver print. This doll resembles the "Tynie Baby" model produced by Horsman.

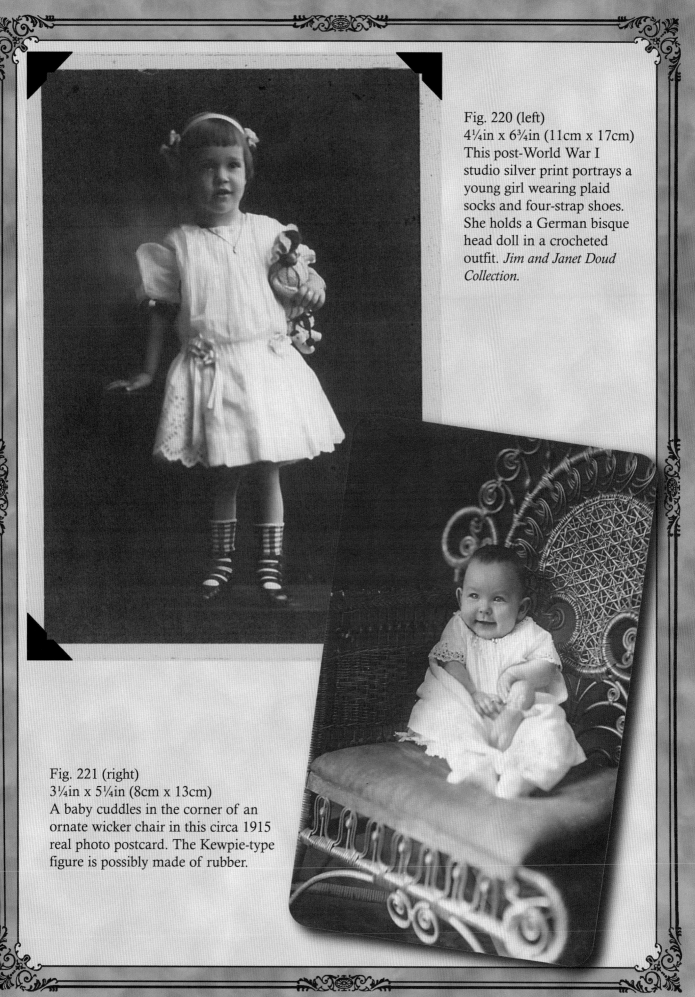

Fig. 220 (left)
4¼in x 6¾in (11cm x 17cm)
This post-World War I studio silver print portrays a young girl wearing plaid socks and four-strap shoes. She holds a German bisque head doll in a crocheted outfit. *Jim and Janet Doud Collection.*

Fig. 221 (right)
3¼in x 5¼in (8cm x 13cm)
A baby cuddles in the corner of an ornate wicker chair in this circa 1915 real photo postcard. The Kewpie-type figure is possibly made of rubber.

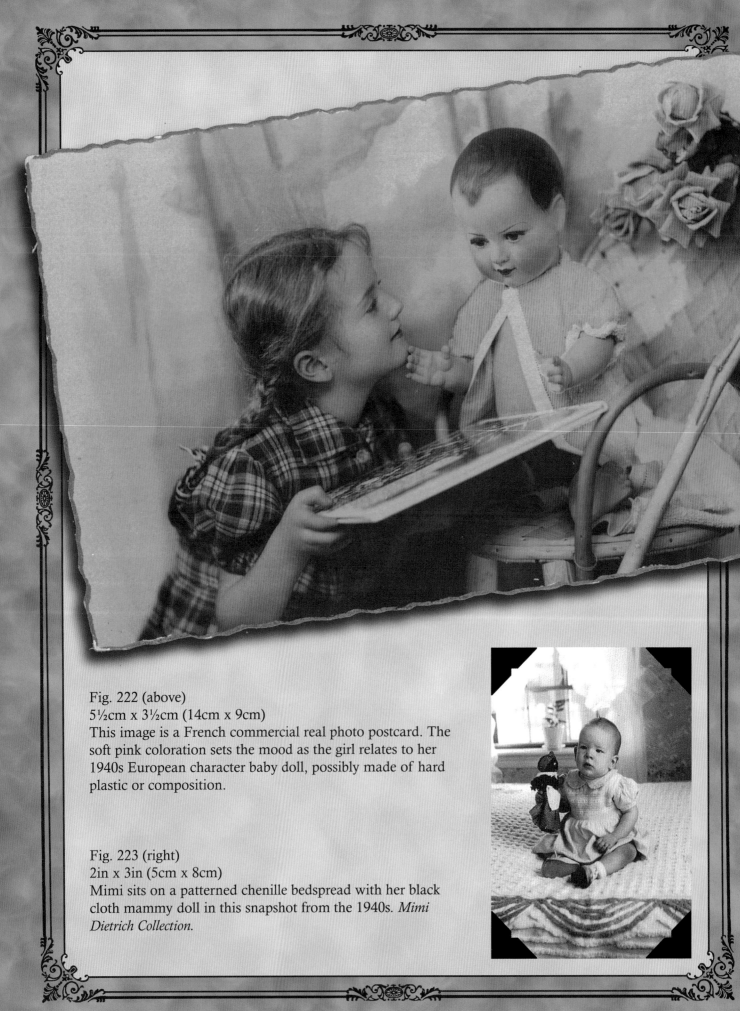

Fig. 222 (above)
5½cm x 3½cm (14cm x 9cm)
This image is a French commercial real photo postcard. The
soft pink coloration sets the mood as the girl relates to her
1940s European character baby doll, possibly made of hard
plastic or composition.

Fig. 223 (right)
2in x 3in (5cm x 8cm)
Mimi sits on a patterned chenille bedspread with her black
cloth mammy doll in this snapshot from the 1940s. *Mimi
Dietrich Collection.*

Fig. 224 (left)
$3\frac{1}{4}$in x $5\frac{1}{4}$in (8cm x 13cm)
A girl in a smocked dress smiles happily for the camera in this 1930s European real photo postcard. She holds her composition child doll that has a wig, sleep eyes, and an open mouth.

Fig. 225 (right)
$3\frac{1}{2}$in x $5\frac{1}{2}$in (9cm x 14cm)
This circa 1915 real photo postcard is a portrait of a little girl with a startled look. She clutches her baby doll tightly as the camera records her expression.

The End

139

Guide to Photographic Terms

The **Daguerreotype** was introduced in France by Louis Daguerre in 1839 and was the first practical photographic process. The image was developed by a complicated single image process on a silver coated copper plate. These cased images lost favor by 1860 and are identified by a mirror image when held at an angle.

The **Ambrotype**, invented by Frederick Scott Archer of England in 1841 and patented by James Ambrose Cutting in the United States in 1844, was a cased negative image made with the wet-plate process on a glass surface. This fragile negative image was viewed as positive when a black backing was added. No copies could be made once the backing was applied. Last produced in 1865, the ambrotype is identified by the absence of a reflective mirror image when compared to the daguerreotype.

The **Tintype**, (also called melainotype or ferrotype) was patented in 1856 by an American, Hannibal Smith. Tintype production was similar to that of the ambrotype with one exception—a thin iron sheet was utilized rather than a glass plate. No copies could be made, but a multi-lens camera allowed duplicates of the image to be taken in one sitting. The popular, durable, and inexpensive tintype was produced into the 20th century, although cased images were made only until 1868. Identification of a cased tintype can be made with a magnet against the glass or when possible, with removal from the case.

The **Image Case**, introduced in 1839, served as a protector for daguerreotypes, ambrotypes and tintypes. Wood frame cases were covered with embossed leather, cardboard, or papier-mâché, while others were molded thermoplastic cases. Some were further decorated with paintings, gilding, or inlays of tortoiseshell or mother-of-pearl. The image case lost favor by the late 1860s.

The **Albumen Print**, invented by Louis-Désiré Blanquart-Evrard in 1850, was a positive image produced from a glass plate negative (wet-plate process) on sensitized paper coated with egg whites. Multiple copies were possible from the glass plate negative. Examples of mounted albumen print formats included the carte de visite, cabinet card, and stereograph. Albumen prints can be identified by fading, yellowing, staining, foxing (brown spots from mold or impurities) and surface crazing.

The **Carte de Visite** was introduced in France by André-Adolphe Eugène-Disdéri in 1854. This small albumen print mounted on cardboard stock (2½in x 4in) was the size of a Victorian calling or visiting card. Small "gem" tintypes were also used in this format after being placed in decorative paper sleeves. The idea of a family album became popular with the affordable and accessible carte de visite. By 1870, its popularity waned with the advent of the cabinet card.

The **Cabinet Card** was developed in 1863 by the London Studios of Windsor & Bridge. Most cabinet cards were albumen prints mounted on cardboard stock (4¼in x 6½in). Bigger albums were required to accommodate this Victorian format, popular between 1870-1900. Many photographers lavishly printed their names on the front and back in elaborate script.

The **Stereograph** was a set of two photographs taken of the same subject from slightly different perspectives. When mounted side-by-side on a cardboard backing and observed through a hand held stereoscope, an image of a three dimensional picture was created. An Englishman, Sir Charles Brewster, invented the stereoscope in 1849. The most common form is the albumen print (1850-1900). Stereograph dating can be determined by the shape and color of the card mount and by the type of photographic process used.

The **Cyanotype**, developed by Sir John Herschel in the 1840s, was a photographic image much like the modern blue print. Popular with amateur photographers from 1890-1910, cyanotypes were primarily used as artist's proofs. Cyanotypes are identified by their distinctive blue color.

The **Silver Print** is a loosely encompassing contemporary term describing paper prints made after the invention of gelatin coated paper in the 1880s. Silver, an important component of the gelatin, helped to produce a photo-sensitive surface on the paper. Many early prints may be identified by silver mirroring, a shiny bluish metallic sheen found on the edges and shadow areas of the image.

The **Real Photo Postcard** was an actual photograph printed on postcard-size stock (usually 3½in x 5½in) from a camera's negative. Examples from 1900-1906 had space on the front for messages, while postcards after 1907 allowed space for messages on the back. Studying the preprinted lettering styles and the stamp box design (the rectangular space for the stamp) on the back of a postcard helps to date an image from 1905-1950.

Photomechanical Reproduction Processes were used by commercial manufacturers to reproduce photographs with a printing press and ink. These processes were less expensive and time consuming than actual photographic printing on light sensitive paper. With the aid of a magnifying glass, collotypes, photogravures, and halftones are easily identified by the presence of dots, lines, curvy shaped patterns, irregular graining, and no fading. In contrast, a real photo will have clarity with no patterns and some degree of fading is usually evident.

Glossary of Doll Terms

The dolls photographed on the preceding pages can sometimes be identified as to maker and type if the doll is facing the camera and the image is clear. The simplified classifications listed below may help the reader in understanding the doll terms covered in this book.

Ball-jointed Body: A doll's body, usually made of composition, with joints at the shoulders, elbows, hips, and knees to allow movement. Wooden balls were placed between the joints to allow more flexibility.

Bent-limb Baby Body: A body used for baby dolls, usually made of composition or papier-mâché with a lifelike plump baby body with gently curved arms and legs.

Bisque: Dolls and/or doll parts made from unglazed porcelain, usually flesh tinted.

Celluloid: Dolls and/or doll parts made from a highly flammable and fragile early plastic material.

Character: A doll made after 1910, usually with a head of bisque or composition, whose mold was designed after a real baby, a child, or an adult. Their animated expressions were very lifelike when compared to the idealized dolly-face dolls of the late 19th century.

China: Dolls and/or doll parts made from glazed porcelain, characterized by a shiny surface.

Cloth: Commercial and handmade dolls and/or doll parts made from cloth of all types, including dolls made from commercially printed fabric, molded felt and/or muslin, and oil painted or treated fabric.

Composition: Doll and/or doll parts made from various mixtures of paper pulp, wood pulp, cloth, plaster, sawdust, glue and other assorted materials. Early examples of dolls of this type were often made of papier-mâché composition. Later twentieth century dolls of this type were often made with wood pulp composition.

Dolly-face Dolls: Bisque head dolls that were made to represent idealized full-faced children and were popular from about 1880 to 1910. Characteristics included glass eyes (sometimes with a sleep mechanism), painted closed mouths or open mouths with teeth, and mohair or human hair wigs. Their bodies were usually made of leather, cloth, or composition.

Frozen Charlotte: An unjointed all china or all bisque doll with molded features, usually without clothes.

Hard Plastic: dolls and/or doll parts made from a sturdy synthetic material produced after 1945.

Kid Body: A sewn leather body sometimes with appendages of bisque, composition, or cloth. Kid bodies were stuffed predominately with cork, horsehair, or saw dust.

Mama Doll: A 20th century American composition head doll made with a cloth body and a mama voice box. The arms and swinging legs were usually made of composition.

Papier-mâché: Dolls and/or doll parts made from a special kind of composition consisting of paper pulp, glue, and various other ingredients.

Parian: Pale or untinted bisque head dolls, popular from 1860 to 1880, often representing a lady with a fancy molded hairstyle.

Patent Washable: Dolls made with a papier-mâché composition head from 1880 to 1910. Common characteristics were glass eyes, a mohair or skin wig, an open or closed mouth, cloth body, and composition appendages often with molded boots. Although advertised as washable, they could only be gently cleaned with a damp cloth.

Vinyl: Dolls and/or doll parts made of a soft plastic material, that was predominately used after 1950.

Wax: Dolls and/or doll parts of the 1800s made from molded poured wax, reinforced wax lined with plaster composition, or wax-over. Wax-over dolls were made of papier-mâché composition, wood, or other materials that were dipped in wax. Some had appendages of carved wood. The earliest wax-over models had slits made in the tops of their heads to accommodate a wig.

Wood: Dolls and/or doll parts made of carved or turned wood.

Selected Bibliography

American Victorian Costume in Early Photographs, by Priscilla Harris Dalrymple (Dover Publications, Mineola, New York, 1991).

Blue Book: Dolls & Values, 14th Edition, by Jan Foulke (Hobby House Press, Inc., Grantsville, Maryland, 1999).

The Camera and Its Images, by Arthur Goldsmith (Newsweek Books, New York, New York, 1979).

Care and Identification of 19th Century Photographic Prints, by James M. Reilly (Eastman Kodak Co., 1986).

Chinas: Dolls for Study and Admiration, by Mona Borger (Borger Publications, San Francisco, California, 1983).

Cloth Dolls of the 1920s and 1930s, by Polly Judd (Hobby House Press, Cumberland, Maryland, 1990).

Collector's Encyclopedia of American Composition Dolls: 1900-1950, by Ursula R. Mertz (Collector's Books, Paducah, Kentucky, 1999).

The Collector's Encyclopedia of Dolls, by Dorothy S. Coleman, Elizabeth A. Coleman and Evelyn J. Coleman (Crown Publishers, New York, New York, 1968).

The Collector's Encyclopedia of Dolls, Volume Two, by Dorothy S. Coleman, Elizabeth A. Coleman, and Evelyn J. Coleman (Crown Publishers, New York, New York, 1986).

Collector's Guide to Early Photographs, by O. Henry Mace (Wallace-Homestead Book Company, Radnor, Pennsylvania, 1990).

Dressed for the Photographer: Ordinary Americans and Fashion, 1840-1900, by Joan Severa (Kent State University Press, Kent, Ohio, 1995).

German Doll Encyclopedia: 1800-1939, by Jürgen and Marianne Cieslik (Hobby House Press, Cumberland, Maryland, 1984).

German Doll Studies, by Jürgen and Marianne Cieslik (Gold Horse Publishing, Annapolis, Maryland, 1999).

Hard Plastic Dolls: Identification & Price Guide, by Polly and Pam Judd (Hobby House Press, Grantsville, Maryland, 1994).

History of Photography, by Beaumont Newhall (Museum of Modern Art, New York, New York, 1982).

The Jumeau Book, by Francois Theimer and Florence Theriault (Gold Horse Publishing, Annapolis, Maryland, 1994).

Keepers of Light, by William Crawford (Morgan and Morgan, Dobbs Ferry, New York, 1979).

Kestner King of the Dollmakers, by Jan Foulke (Hobby House Press, Cumberland, Maryland, 1989).

Kewpies - Dolls & Art of Rose O'Neill & Joseph L. Kallus, by John Axe (Hobby House Press, Cumberland, Maryland, 1987).

The Picture History of Photography: From the Earliest Beginnings to the Present Day, by Peter Pollack (H.N. Abrams, New York, New York, 1969).

Prairie Fires and Paper Moons: The American Photographic Postcard, 1900-1920, by Hale Morgan and Andreas Brown (David R. Godine, Boston, Massachusetts, 1981).

Second Edition Collector's Guide to Early Photographs, by O. Henry Mace (Krause Publications, Iola, Wisconsin, 1999).

Simon and Halbig Dolls: The Artful Aspect, by Jan Foulke (Hobby House Press, Cumberland, Maryland, 1984).

Twentieth Century Dolls, by Johana Gast Anderton (Wallace-Homestead, Lombard, Illinois, 1986).

Victorian and Edwardian Fashion: A Photographic Survey, by Alison Gernsheim (Dover Publications, New York, New York, 1981).

Photographic Attributions

Figure numbers not listed denote origins unknown.

3: Nelson Studio's, Dike & Grundy Center, Iowa. 4: Wilke, 393 Blue Island Ave., Chicago. 9: Page from the book *Mother Goose of '93*, photographic illustrations by Mrs. N. Gray Bartlett, Boston J. Knight Company (1893). 11: Orgill Photographer, 281 Main St. corner Pearl, Hartford, Conn. 16: Blumenstiel, Charles City, IA. 18: H. Sonnenburg, Turtle Creek, Pa. 19: Macy & Co., 241 Main St., Northhampton, Mass. 22: LE Paris in shield symbol, 860, Editions Superluxe - Paris, Photo

Véritable. 23: Decker, Mt. Vernon, Mo. 24: Lovewell, Dubuque. 26: Amag in circle symbol, 62270/3. 30: Shinn, Pittsfield, Ill., Girggsville, Ill. 31: Illegible signature. 35: Misange, 130, Made in France. 36: Underwood & Underwood, Publishers, New York, London, Toronto-Canada, Ottawa-Kansas, copyright 1892. 38: DLG in circle symbol 253/i. 39: I.J. Lethen, Minnewaukon, N. Dak. 41: NiQ in logo arrangement, 1118. 47: W.T. Crouch, Belleville, ILL. 48: J.A. Fairbanks, Artist, Center Point, Iowa. 52: Verlag Carl Werner, Reichenbach i. Vogtl, Werner Farbfoto, No. 1225. 55: Brown, No. 19 West Main St., Marshalltown, Ia. 56: RPH in circle symbol, 1799/l. 57: C.B. Strawn's Studio, Massena, Iowa. 59: Rising sun symbol, 2926. 60: Illegible stamped logo. 63: F. Fortin, Cor. 2nd Cherry Sts., Alton, ILL. 67: EAS in heart symbol, 7274/2. 68: FURIA, 287, Fabrication Francaise. 70: H.R. Freeboen & Son, 417 Walnut St., Des Moines, Iowa. 71: F.A. Gilbert, Photographer, 211 Broadway, So. Boston. 75: CB logo, Paris, 785, Fabrication Francaise. 86: C.R. Savage, 12814 Main St., Salt Lake City. 87: T.H. Sullivan, Garrett, Ind. 88: Tin easel symbol, Raphael Tuck & Sons' "Framed Gem" Birthday Series No. R 2311, Art Publishers to the King and Queen, Processed in Saxony. 89: Photo-Atelier J. Gross, Wien, Il., Taborstr. 48a. 91: Wrau '27 in logo. 96: KKHG in logo, 1722/5. 97: C.A. Gale, Cabinet Portraits, Extra Finish, Art Parlor, 411 1-2 Main St., Pique, Ohio. 100: Burgert. 71½ W. Bay St., Jacksonville, Florida. 101: LL with crossed arrows in circle symbol, 425/6 102: T. Morgan. Blaenogwy. 105: CB in circle symbol, 3108. 109: Chas. LaRush, Artist. 114: Smoot, So. Milwaukee, Wis. 118: Fotocelere in script logo, 135/3, Paris, Fabrication Francaise. 120: AL in logo, 3167/4. 121: To H. R. H. The Prince of Wales, Norman May, The Priory Mount, Malvern, Oborne, London & Paris. 122: Norman Maye Ye Priory Mount, Malverne, Entered at Stationers Hall, Oborne, London & Paris. 123a, b: J.M. Young, Llandaudno, North Wales, Patronized by H.M. The Queen. 124: E.L. Logan, Pratt, Kansas. 126: Pencil signature NC Marrey. 128a, b: Rudolph's Studio, 957 Milwaukee Ave., Chicago. 129: Geo. W. Griffith Publisher, Philadelphia, Pa., Copyright 1901. 130: Lovell, Oswego, N.Y. 131: PG in circle encased in diamond symbol, 429/30. 132: W.B. Field, Photographer, Morris, ILL. 134: Delores Prochaska family photograph. 135: Jno. P. Vail, photographer, Smith's New Block, Geneva, N.Y. 137: CB in letter logo, Paris, 785, Fabrication Francaise. 138: W. McLennan & Co., Greenock, Corner of West Blackhall & Nicolson Streets. 139: Dora Clark Tash, Formerly Flagg & Plummer, Lewiston, Me. 141: North Side Art Gallery, Geneseo, Illinois. 142: Eline Andersen, Helsinger. 143: P. Holgerson, Cor. North & Western Ave., Chicago. 146: Lori McMurray Farmer family photograph. 147: Artchrom, Dep. Serie 3025, Printed in Saxony. 148: C.A. Krebaum, LaCrosse, Wisconsin. 150: EAS in heart symbol, 357. 151: A.L. Bagne, Superior Finish, Waseca, Minn. 154: J.J. Foster, Traveling Photographer. 155: RPH in circle symbol, 58251/1, Kunstveriag August Gunkel, Düsseldorf. 157: R & KL in half sun symbol, 457211, H.E. Kiesel, phot., The LN, "Castle" Series of Post Cards, Printed in Saxony. 158: Flagg & Glummen, Lewiston, ME. 159: J. Smrcek. 160: G.A. Flach, Photographer and Oil Portrait Artist, 1000 Third Avenue, New York. 162: 1439/3, printed in Germany. 166: Mary McMurray Wikert Family photograph. 167: Mary McMurray Wikert Family photograph. 168: Clifford & Son, 210 and 212 Cedar St., Muscatine, Ia. 171: Nickols Studio, Indianola, Ia. 172: Knight Series, chess horse symbol, 1807, Knight brothers, England, Printed in Berlin. 173: Brown. 174: 398 D.B. Davidson Bros Real Photographic Series, London & New York, Printed in England. 175: Rasmussen, Rock Island, Ill. 176: Allen & Perkins, Seattle, Wash. 6105½ 13th Ave. S, Georgetown Station. 179: Min oval symbol, 1006, Made in France. 181: Chas F. Meier, 1406 So. Broadway, St. Louis, Mo. 182: N. Jenks, Cartes de Visites, Boonvill, N.Y. 183: Gilbert Studio. 185: Alelier Helios Vöslau. 188: L.O. Tilford Studio, 274 Essex St., Salem, Mass. 189: A. Heinemann, 4938 Ashland Ave., Bet 49 & 50th Sts., Chicago. 190: Photographs of Art, Ernsberger & Ray, 83 Genesee Street, Auburn, N.Y. 196: Photo-Manufakur E. Jelussich, Abbazia-Fiume-Lovrana-Cirkvenica. 197: Gilhousen, Kahoka, Mo. 200: Knight Series, chess horse sympbol, 1803, Knight Brothers, England, Printed in Berlin. 202: Dufresne, Cor. Second & Madison, Sts., Watertown, Wis. 204: A L letter logo, 3167/3. 205: Ebberstein, Helena, Ark. 206: RTB in circle symbol, 3582. 208: Mary McMurray Wikert family photograph. 209: Jaeneke, 1031 3rd street, Milwaukee. 210: Th. E.L. "Emaille" Series, 3031, Printed in Germany. 212: Verlag Carl Werner, Reichenbach i. Vogtl., Werner Farbfoto. 219: The Nina Wayne Grau Studio. 222: LE in shield symbol, Paris, 860, editions Superluxe, photo Veritable. 223: Mimi Dietrich family photograph. 224: Photo-scheidl, Munchen 19, Winthirstr. 2-1. 225: Rydholm Studio.

About the Authors

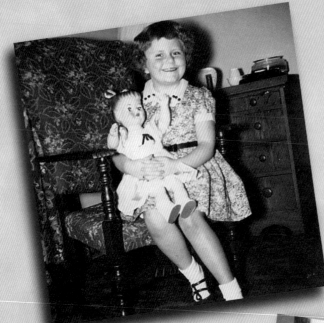

Mary McMurray Wikert

Mary was raised and educated in the Midwest, graduating from the University of Iowa with a degree in arts education. She has taught thousands of students on all grade levels in her art position with the public schools. Mary has completed additional graduate work and research, and feels her strongest emphasis and interests are in the areas of art history, costume design, illustrative drawing, and the decorative arts. She is a past president and a member of a nationally federated doll club and is a knowledgeable doll historian. Her intense interest in historical photographs grew from her love for antique dolls and toys. Raising two sons in Cedar Falls, Iowa, with her husband, Steve, has strengthened her convictions of preserving images of children with the things they cherish.

Steven Micheal Wikert

Steve, who was formerly a municipal cultural director, is now an arts educator in the public schools, a visual artist, a knowledgeable photographer, and a published poet. He was raised in Iowa and returned there after his service in the U. S. Navy and Vietnam. Studying arts education, public relations, and educational administration, he has earned a BA, an MA, and an Advanced Studies Certificate from the University of Northern Iowa. He and his wife, Mary, have raised two sons in Cedar Falls, Iowa. He has a love for vintage teddy bears and many other antiques. His personal/professional background and his many years of collecting antique photographs, have heightened Steve's ability to discover quality images of children with the things they cherish.

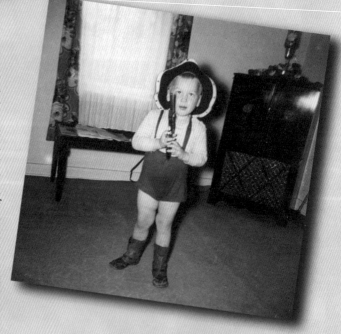

Other Books In This Series Include

Cherish Me Always: Teddies and Warm Fuzzies
Cherish Me Always: Animal Friends (Spring 2002 release)
Cherish Me Always: Images of Christmas Past (Fall 2002 release)